SUFFRAGISTS
IN WASHINGTON, D.C.

SUFFRAGISTS
IN WASHINGTON, D.C.

The 1913 Parade and the Fight for the Vote

*To Melanie
with admiration*

REBECCA BOGGS ROBERTS

THE
History
PRESS

Published by The History Press
Charleston, SC
www.historypress.net

First published 2017

Manufactured in the United States

ISBN 9781625859402

Library of Congress Control Number: 2017953975

Notice: The information in this book is true and complete to the best of our knowledge. It is offered without guarantee on the part of the author or The History Press. The author and The History Press disclaim all liability in connection with the use of this book.

To my extraordinary grandmother Lindy Boggs, born before women could vote, who taught me to use that power wisely and often.

CONTENTS

ACKNOWLEDGEMENTS

I first came across the 1913 march in Washington, D.C., in 2010, when I was working at Historic Congressional Cemetery. It was the ninetieth anniversary of the ratification of the Nineteenth Amendment, and I was trying to determine if there were enough suffragists buried at Congressional to create a special tour of their graves. As I combed through hundreds of obituaries, I found the 1913 march referenced again and again. Socialite hostess Marguerite DuPont Lee contributed money. Scholar Elizabeth Brown marched with the teachers and testified in the Senate hearing that followed. Sculptor Adelaide Johnson marched with the artists and was inspired to create the "Portrait Monument" that sits (finally!) in the Capitol Rotunda. Pioneering lawyer and 1884 presidential candidate Belva Lockwood held pride of place near the very front of the procession. This march formed a seminal moment in the lives of these women, just as it did for the entire suffrage cause. The tour that resulted, delightfully called "Uppity Women," is available for download on the cemetery's website. And although the role of the 1913 procession is dutifully acknowledged in histories of the American suffrage movement, it has been entirely forgotten in the context of protest marches on Washington. Marching on Washington, it seemed, was a spontaneous idea of the civil rights movement in the 1960s. The oversight has always bothered me.

Then the 2016 election happened, and women once again planned a massive protest march in Washington to coincide with the inauguration of a new president. The parallels were too strong to ignore. And so the idea for this book was born.

But it wouldn't have progressed beyond an idea without the help and support of a great many people. The wonderful staffs of the Library of Congress, the Belmont-Paul Women's Equality National Monument, the McClung Historical Collection and the Museum of London have all proven invaluable. I have relied heavily on Robyn Leigh Muncy's research about the years immediately following the amendment. My mother, Cokie Roberts, who knows a thing or two about the power of women in history, provided constant cheerleading and really good editing. My colleagues at Smithsonian Associates, unquestionably a bunch of Uppity Women, were unfailingly patient and supportive while I surely bored them with my enthusiasm. And my husband and three sons cheerfully accepted the days I completely opted out of our busy family life in order to chain myself to my laptop and write. Thank you all so, so much.

THE GREAT SUFFRAGE PARADE
OF 1913

L uckily, Monday, March 3, 1913, dawned bright and clear. It was cold, but that would only really be a problem for the barefoot dancers on the marble steps of the Treasury Department. Rain or snow would have been disastrous. A little chill could be expected in Washington in early March, and everything that could be expected had been planned for. The marchers were set to gather at two o'clock near the Garfield monument on Maryland Avenue, and Grand Marshal Jane Burleson would lead them out into Pennsylvania Avenue at exactly three o'clock. A daisy chain of trumpeters would pass the news down the parade route that the march was underway, and the fantastic allegorical pageant would begin on the Treasury steps. It would take Burleson and her attendants about forty-five minutes to lead the procession the mile and a quarter from the Peace Monument in front of the Capitol to the site of the pageant. By the time parade herald Inez Milholland reached the steps in front of the Treasury Department, the pageant would be coming to its glorious dramatic finale, and the participants would stand in dignified silence as the rest of the five thousand marchers proceeded down the parade route to Continental Hall. The pageant cast would join them there later and perform the final tableau again for the triumphant crowd.

No detail had been overlooked. Alice Paul made sure of it. This whole spectacle was her brainchild, and she had begun making plans and assigning tasks even before the National American Woman Suffrage Association (NAWSA) had endorsed the idea or given her an official title. Now Alice Paul

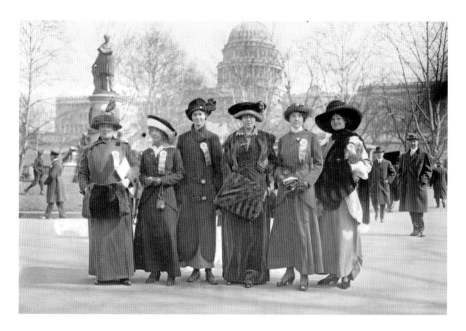

Suffragists gather at the Capitol, preparing for the great suffrage parade of 1913. *Library of Congress.*

was head of NAWSA's Congressional Committee and chair of the parade committee. She badgered D.C. police chief Richard Sylvester into granting her a permit to use Pennsylvania Avenue. She lobbied the House Committee on the District of Columbia to pass a bill shutting down the streetcars between three and five o'clock. She used her connections in the Taft White House to make sure there was a cavalry unit standing by at Fort Myer, in case the D.C. police provided inadequate crowd control, although Chief Sylvester assured her that wouldn't be necessary. She negotiated with the inaugural committee to use the grandstand constructed at Fourteenth Street so distinguished guests could watch the pageant and then enjoy the parade. Her public relations machine was relentless, making sure the march had been in the news so often and so thoroughly that it was almost considered one of the formal celebrations of Woodrow Wilson's presidential inauguration. Paul fed pithy quips to reporters wanting responses to the antics of the anti-suffrage crowd. She held daily, sometimes hourly, rallies and fundraisers. She kept track of dozens of special train cars that carried hundreds of suffragists to Washington, each of whom needed a place to stay and wanted special attention. She arranged for local Boy Scouts to line the parade route. She encouraged local women's clubs to sell sandwiches and scalloped oysters to

the spectators. One planning volunteer remarked she had worked with Paul for three months before she found time to take her hat off.

Then there were the details of the parade itself. Jane Burleson and her attendants, both on horseback and on foot, would lead. Next came the striking figure of Inez Milholland, routinely described as "the most beautiful suffragist," in flowing white robes and a golden crown atop a glamorous white horse. Behind her followed a wagon with a massive sign called the "Great Demand Banner." It read, "We demand an amendment to the Constitution of the United States enfranchising the women of this country." And after that, no fewer than *seven* sections of marchers. Representatives of the few nations with full suffrage (New Zealand, Australia, Finland, Norway) each designed a float ridden by costumed participants. The nations where women enjoyed partial suffrage carried banners and donned more costumes. A series of floats represented the changing status of American women since the suffrage movement began in the 1840s. Professional women, all in matching thematic dress, were organized by occupation. The writers' group had purposefully stained their costumes with ink. The states where women could vote each sent a delegation, including members of Congress who had to sneak past the sergeant at arms to participate, since Congress was actually in session. Golden chariots. Women's marching bands. College women grouped by alma mater. A massive reproduction of the Liberty Bell. "General" Rosalie Jones and her army of pilgrims, who had hiked all the way from New York. Everything was designed to be visually striking for the live show and look great in photographs.

The allegorical tableaux on the Treasury Department steps were similarly well designed. Dozens of women and girls in classical costumes created scenes meant to represent Columbia summoning Justice, Charity, Liberty, Peace, Plenty and Hope to the stirring sounds of "The Star-Spangled Banner" and the Triumphal March from *Aida*. Paul hired professionals to plan the pageant, wanting to make sure this show surpassed the amateur theatrics of past suffrage events. The whole procession cost an astounding $14,906.08, but it was money well spent. The spectacle would surely stand in stark contrast to the official Wilson inaugural parade planned for the next day, which organizers had bragged would be marked by "Jeffersonian simplicity and dignity."

Not all the planning went smoothly. The newspapers loved General Jones and her hikers, and their publicity threatened to overshadow the march. They had arrived in Washington just the day before, to a hero's welcome from the public. But their reception from the local suffragists was markedly

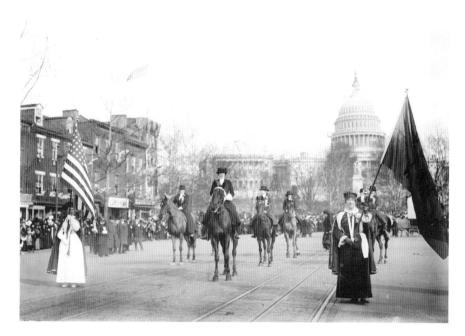

Grand Marshal Jane Burleson leads the parade. *Library of Congress.*

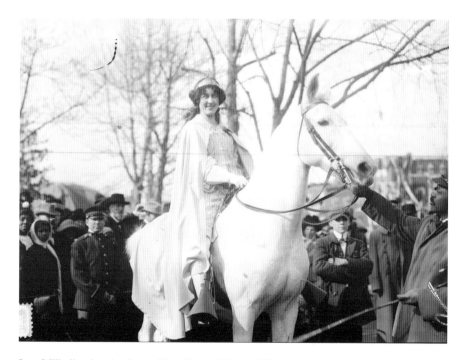

Inez Milholland on her horse Gray Dawn. *Library of Congress.*

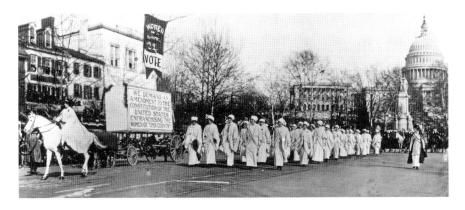

The front of the procession with the "Great Demand" banner. *National Archives.*

cooler, and General Jones had noticed. Paul also faced a dilemma about how to handle a group of African American women from Howard University who wanted to march with the college groups. Paul was torn: as a Quaker, she did not want to discriminate based on race. But as an organizer, she worried delegations of southern women would drop out if the march were integrated. Finally, the Howard women were allowed to join but were not listed in the official program.

And then there was the petty squabble over the colors for the banners leading each section. Paul had originally hoped for a scheme of green, white and violet, the colors of the suffrage movement in England. In fact, some believed wearing those colors was an undercover way for women to quietly support suffrage, since they began with the same letters as Give Women [the] Vote. But NAWSA officials worried that adopting that palette would be seen as endorsing the more militant tactics of the British suffragists and insisted on the international suffrage colors of white and yellow. Paul chose all of the above. And although photographs of the event are of course in black-and-white, contemporary accounts of the parade never fail to mention the riot of colors. Every last detail was meticulously planned to make sure the spectacle was grand, important and memorable.

It started out pretty well. Pennsylvania Avenue looked awfully crowded to Burleson, and the policeman she asked for reassurance was singularly unhelpful. But she was able to start the parade only fifteen minutes late, and the first trumpet herald dutifully sent the signal down the route to the next trumpeter, and so on fourteen blocks to the Treasury building. The pageant began, admired by a packed grandstand. More and more people crowded

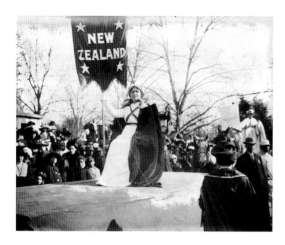

Left: A float representing New Zealand rides among the nations with full suffrage. *Library of Congress.*

Below: The "Nurses" group marches with the professional women. *Washington, D.C. Public Library.*

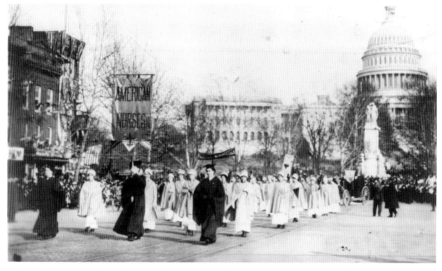

around Fourteenth Street as the show continued. Columbia, dressed in armor, called forth each of the virtues. Justice and her attendants were all dressed in purple. Charity arrived surrounded by adorable children and rose petals. Grand Liberty struck a gallant figure that would feature prominently in news photographs. Peace released a live dove. Plenty and her attendants rushed down the steps to the plaza. Finally, Hope joined the tableau, and the magnificent picture was complete. The folks on the street, who now numbered in the thousands, and the VIPs in the grandstand, including outgoing First Lady Helen Taft, said they were very impressed. At the end of the pageant, the entire cast moved forward in formation to watch for the head of the parade, which was timed to pass at any moment. They waited.

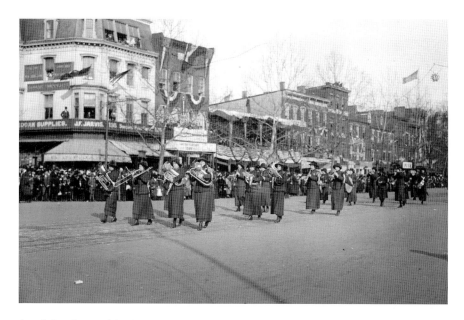

An all-female marching band takes the avenue. *Library of Congress.*

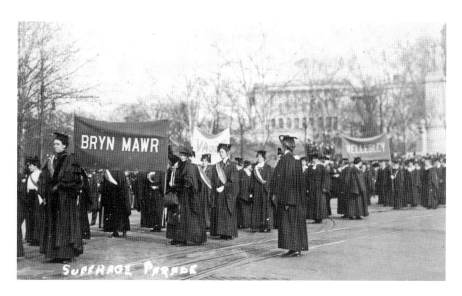

Alumnae of Bryn Mawr, Vassar and Wellesley take their places in the parade. *Library of Congress.*

The suffrage hikers arrive in Washington. *Library of Congress.*

The crowd grew bored. They waited some more. The first lady left. They waited as long as they could. The crowd became gradually less friendly but no less numerous. Finally, after almost an hour, Columbia and the virtues could no longer stand the cold marble on their bare feet and went inside the Treasury building to wait. Where was the parade?

Ten blocks up Pennsylvania Avenue, the parade was stalled. The spectators at Fifth Street had spilled into the road, and there was no way for the marchers to proceed. Jane Burleson looked for the policemen who were supposed to escort her and couldn't find them. From atop her horse, Burleson had a pretty good view down the avenue, and what she saw was a "horrible, howling mob." Despite the assurances of the chief of police, the parade route was not clear, and it looked as though it would not become clear anytime soon. And the thousands of spectators blocking the road were not all friendly. After all, most were men in town for the Wilson inauguration, scheduled for the next day. The suffrage parade was just a sideshow. Alice Paul realized her meticulously planned day was in danger of collapsing. She had put on academic robes, expecting to join her fellow Swarthmore alumnae in the college section. But now she and Lucy Burns got in a car and drove slowly down the parade route ahead of the marchers, trying desperately

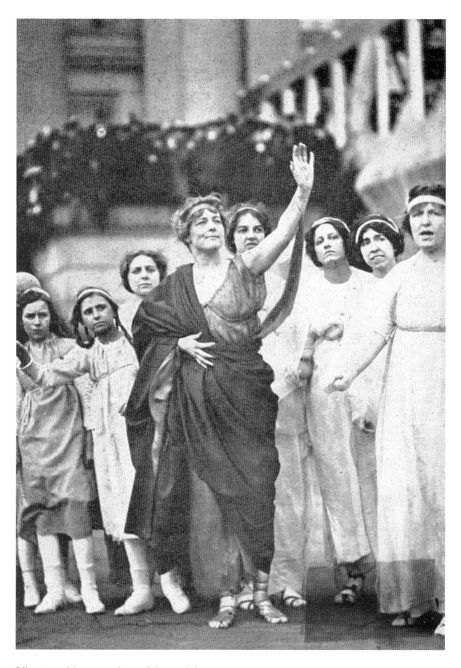

Liberty and her attendants. *Library of Congress.*

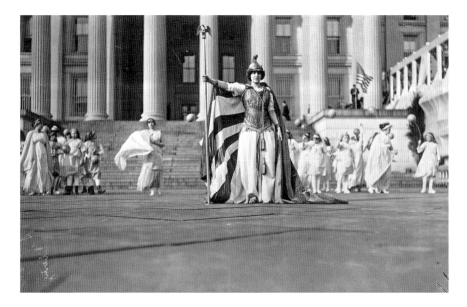

The armored figure of Columbia. *Library of Congress.*

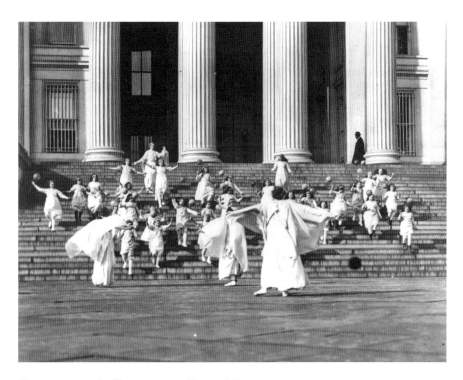

The pageant on the Treasury steps. *Library of Congress.*

to clear a path. As she drove, Paul saw Boy Scouts valiantly holding the crowd back in places, while the policemen did nothing. She saw drunken men yelling insults. She saw the crowd surge back into the marchers' way as soon as her car had passed.

There was nothing for it but to press on. Burleson and Milholland gamely led the way, stopping and starting, narrowing the march formation to single file where the spectators crowded the avenue. The women began to feel increasingly threatened. Some of the marchers on horseback fought back, kicking out at the crowds with their boots. Some of the women on foot used batons and flags to push the more aggressive men back. Burleson and Milholland fought their way nine more blocks to Fourteenth Street. But it was slow going, and the crowd was getting less orderly and more hostile. They were over an hour late for the pageant.

Meanwhile, President-elect Woodrow Wilson and his party arrived at the train station just a few blocks away. Only a modest crowd met them there. Apparently, Wilson asked, "Where are all the people?" The police answered, "Watching the suffrage parade."

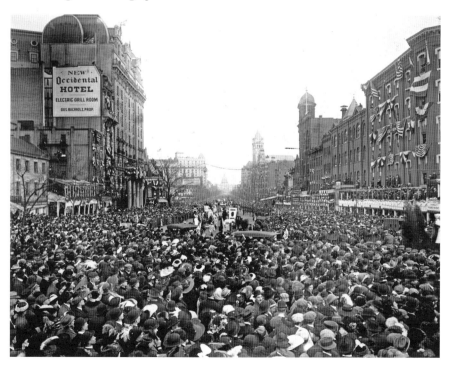

Spectators blocking the parade route. *Library of Congress.*

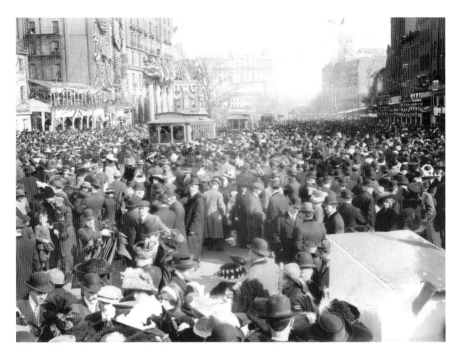

The crowd overflows Pennsylvania Avenue. *Library of Congress.*

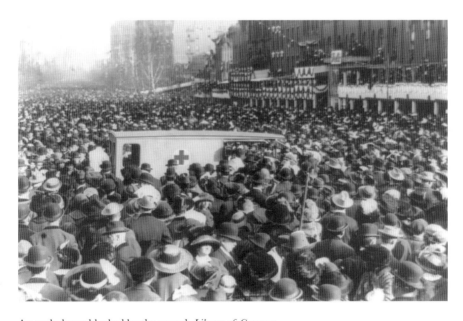

An ambulance blocked by the crowd. *Library of Congress.*

By now, the crowd numbered in the hundreds of thousands. Finally, District officials literally called in the cavalry. The horseback troops standing by at Fort Myer met the head of the parade at Fourteenth Street and rode back up the parade route toward the Capitol, pushing the crowd back with their horses. They weren't gentle, but they were effective. As the *Washington Post* reported, "Their horses were driven into the throngs and whirled and wheeled until hooting men and women were forced to retreat. A space was quickly cleared." The later sections of the parade had more room but no more support from the crowd. They were jeered, grabbed, spat upon, shouted at and tripped. Many policemen did nothing to control the crowd, and some even joined in their taunts. Inevitably, injuries occurred. The *Washington Post* described two ambulances that "came and went constantly for six hours, always impeded and at times actually opposed, so that doctor and driver literally had to fight their way to give succor to the injured." At least one hundred people were taken to the local emergency hospital.

Most of the marchers eventually made their way to Continental Hall. But instead of a triumphant capstone to a perfect day, the rally became a meeting of indignation and protest. Very little had gone according to plan. Helen Keller, who was scheduled to speak, was so frightened by the crowds at the grandstand that she could not participate. Every woman in the hall was some combination of filthy, battered, exhausted, unnerved, insulted, weepy, furious and freezing. Still in her academic robes, Alice Paul surveyed the room. And then she smiled. It was perfect.

Chapter 1

Sixty-Five Years and
Not Much to Show for It

1848–1912

The Great Suffrage Parade of 1913 was a turning point, a revival of energy and effort for a movement that was unquestionably flagging. The American women's movement was born at the Seneca Falls Convention and laid out in the Declaration of Sentiments drafted there. Suffrage was just one of many resolutions (and by far the most controversial one) in that remarkable document, modeled on the Declaration of Independence. But the Seneca Falls activists wrote that declaration in 1848—long before most 1913 marchers were born. The America of 1848 was a very different place—pre–Civil War, pre–light bulb, pre-car. Wisconsin had just been admitted as the nation's thirtieth state. In most of those states, it was still illegal for married women to own property. Very few women went to college, and no African American woman or woman west of the Mississippi River had yet earned an undergraduate degree. The average life expectancy was around forty years. In short, 1848 America was a world almost unimaginable to the Progressive-era women of the early twentieth century.

In the early days of the movement, Susan B. Anthony, Elizabeth Cady Stanton, Lucretia Mott and Lucy Stone emerged as brilliant strategists and fearless campaigners. Their first goal was simply public education. As Stanton wrote in her diary, "If I were to draw up a set of rules for the guidance of reformers…I should put at the head of the list: Do all you can, no matter what, to get people to think on your reform, and then, if the reform is good, it will come about in due season." Stanton did not distinguish

between positive and negative publicity. Anything that got "people to think on" women's rights was productive in her view. Many of the reformers inspired by Stanton and the others were already involved in temperance and abolition. Indeed, many women came to the cause of suffrage because they thought having the vote was the only way they would achieve those other reforms. The temperance movement in particular was a haven for women who wanted to effect social change before the women's movement existed. Since the founding of the American Temperance Society in 1826, women had stressed that as defenders of the home, not to mention inevitable targets of drunken rages and victims of depleted savings spent on drink, they had a uniquely righteous voice in the fight against the evils of alcohol abuse. Those movements were invaluable to the early suffragists, as they provided the equivalent of a field school in fundraising, public organizing and petition drives. They also provided experience in public speaking to often-hostile crowds.

But collaboration with the abolitionists also led to the first major rift in the suffrage movement. The movement could take credit for a few victories in the 1850s and '60s, mainly greater property rights for married women and some gains in women's education. But progress proceeded in a piecemeal, state-by-state fashion, and women still could not vote anywhere in the United States. When the Civil War broke out, the women halted almost all political action in favor of supporting the war effort and the emancipation of slaves. They had many allies among the abolitionists, and surely the national focus on freedom and civil rights would help their cause, they reasoned. But when the Fourteenth Amendment was adopted in 1868, it specifically limited the preservation of the right to vote to "male citizens." It is the first reference to sex anywhere in the Constitution. By contrast, the Fifteenth Amendment, passed in 1869, was notable for its omission of sex. It prohibited disenfranchisement "on account of race, color, or previous condition of servitude," but denying the right to vote on account of sex remained perfectly legal. These word choices were no accident. The word "male" was added to the Constitution *because* of the women's suffrage movement—back when women's voting rights weren't even discussed, gender-neutral terms sufficed.

The suffragists, predictably, were incensed. Even the most supportive of their former abolitionist allies supported the new amendments as written, telling women this was "the Negro's hour" and their time would come. Many women, including Lucy Stone, agreed. Stanton and Anthony, however, decided they could not support the enfranchisement of black men without

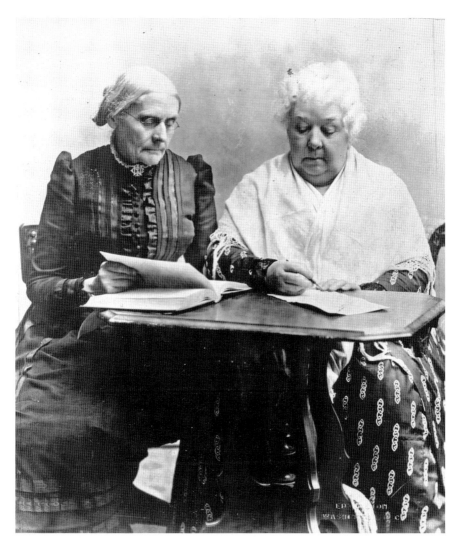

Susan B. Anthony and Elizabeth Cady Stanton. *Library of Congress.*

the inclusion of American women. "If that word 'male' be inserted," wrote Stanton, "it will take us a century at least to get it out."

Using the Fifteenth Amendment as a model, Stanton and Anthony turned the focus of the suffrage movement to a new constitutional amendment enfranchising women. In 1869, they formed the National Woman Suffrage Association and began publishing a newsletter called *The Revolution.* Male members were rare and did not hold leadership positions.

Fearing NWSA's agenda was too bold and its tactics too radical, Lucy Stone and Julia Ward Howe (of "Battle Hymn of the Republic" fame) formed the competing American Woman Suffrage Association (AWSA). Abolitionist Henry Ward Beecher was named president. Its newsletter was called *The Woman's Journal.* AWSA worked principally to add suffrage amendments to state constitutions.

The two groups worked in parallel for years, at times cooperative, more often competitive. Little progress was made. The AWSA's strategy found the most success in the new western territories that were not yet states. Bills for universal suffrage failed in the Washington and Nebraska Territories, but at least they were debated. In the Dakota Territory, women's suffrage lost by just one vote in early 1869. Then in December of that year, the Wyoming Territory became the first government in the world to guarantee women the right to vote. For a big, new, sparsely populated area, universal suffrage made sense. It maximized the voting pool. It attracted national publicity. And, the territorial government hoped, it might attract women. Men outnumbered women in 1870s Wyoming by six to one; local politicians hoped the right to vote might appeal to women back east, where gender ratios were lopsided the other direction by the death toll of the Civil War. Of course, it wasn't all apolitical. The Democrats in the territorial legislature worried that newly

Suffrage "Newsies" sell *The Woman's Journal. Library of Congress.*

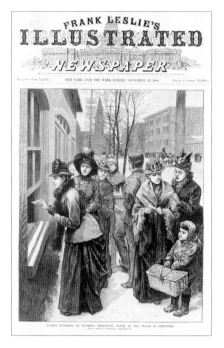

Wyoming women cast their ballots. Frank Leslie's Illustrated Newspaper, *November 24, 1888.*

enfranchised blacks would vote for Republicans, and they hoped female voters would even the balance with Democratic votes. In fact, when Wyoming's women voted majority Republican, the Democrats in the legislature tried to repeal universal suffrage. But the Republican governor vetoed the effort, and Wyoming's historic law remained.

In the election of 1872, Susan B. Anthony and other women cast ballots in Rochester, New York, arguing that they were citizens as defined by the Fourteenth Amendment and therefore had the right to vote. Anthony was arrested a few days later. In a move that would become familiar later in the movement, she insisted on a trial, knowing it would bring national publicity. In fact, in the months between her arrest and trial, she went on an exhaustive lecture tour, quoting the Declaration of Independence, the Constitution, James Madison, Thomas Paine and anyone else she thought would bolster her argument. When she was finally tried in June 1873, the judge found her guilty and ordered her to pay a $100 fine and trial costs. Anthony refused, almost hoping they would throw her in jail and public sympathy would swing her way. But she was set free, and no real attempt was ever made to collect the fine. Anthony always boasted that she never paid a penny. This incident would become an inspiration for twentieth-century radical suffragists.

In 1878, NWSA drafted what came to be called the Susan B. Anthony Amendment. It did not make any general statements about citizenship and the right to vote. It simply prohibited disenfranchisement on account of sex. It was voted on only once, when it was soundly defeated in the Senate in 1887. It was introduced in every single Congress after that and went exactly nowhere.

In the forty years after Seneca Falls, a new generation of suffragists came of age. Harriot Stanton Blatch (Elizabeth Cady Stanton's daughter) and

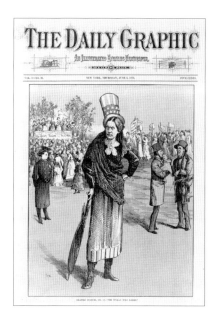

A caricature of Anthony on the lecture circuit. Daily Graphic, *June 1873.*

Alice Stone Blackwell (Lucy Stone's daughter) encouraged the older women to overcome their differences and unite behind their common cause. In 1890, the NWSA and AWSA merged to form the National American Woman Suffrage Association (NAWSA), with Stanton as president, Anthony as vice president and Stone as chair of the executive committee. Together they received news of the very first state (as opposed to territory) to grant women the right to vote, enshrined in Wyoming's first constitution upon joining the Union in 1890. Colorado became the first state to enfranchise women by popular vote in 1893. In 1896, Idaho voted for suffrage, and Utah included it in its first state constitution. Women in these states had full voting rights, including for federal elections. But after this little flurry, anti-suffrage forces began to organize. There was, of course, overt sexism behind the anti-suffrage cause. Plenty of men (and some vocal women) claimed women just weren't intellectually or physically built for the manly task of self-government. But for the most part, the best-organized opposition came from special interests that worried female voters would restrict or prohibit their businesses. These included the liquor lobby, corrupt party machines and industrialists who relied on child labor and unregulated working conditions, all of whom assumed female voters would be more reform-minded than their male counterparts. With these groups taking active measures to prevent suffrage from being introduced more widely, the total number of states with universal suffrage remained at four until 1910.

That was not for lack of trying from the NAWSA. Stanton stepped down in 1892, when she was seventy-seven. Anthony took over as president, and Anna Howard Shaw became vice president. Their focus almost entirely shifted to state constitutions, reasoning that congressional representatives from suffrage states would support a constitutional amendment to keep their female voters happy, and therefore, a critical mass of states would make a federal amendment inevitable. The Susan

B. Anthony Amendment was still introduced in each new Congress, but it was largely symbolic.

The state-by-state strategy included many sub-strategies. New York was always a target, since its sheer number of voters and congressional representatives gave it outsized influence. It was also the home of NAWSA headquarters and a place where suffragists felt they had good local connections and allies. The remaining western states looked like good possibilities, too, including California, Washington, Oregon and Arizona.

And some voices within NAWSA began pushing the movement to consider the South. By 1890, white men in the southern states were actively working to limit the voting power of black men. Ironically, it was former abolitionist Henry Blackwell, Lucy Stone's husband and one of the founders of AWSA, who first suggested that enfranchising women would guarantee that white voters would outnumber black voters in the South. Eager to expand their outreach, and still angry about being passed over in the Fourteenth and Fifteenth Amendments, NAWSA officials created a Southern Committee in 1892, with Laura Clay as the chair. Susan B. Anthony and her deputy Carrie Chapman Catt arranged a speaking tour through the region. In 1895, NAWSA held its annual convention in Atlanta. Anthony personally asked Frederick Douglass to stay away. At various state constitutional conventions that southern states convened to restrict black voting, NAWSA suggested enfranchising educated, property-holding women to bolster the white vote. The Huntsville, Alabama *Republican* moaned, "No matter how modest a constitutional convention is nowadays, some female suffragist will find it out and insist on making a speech." There is no disguising the racism of this strategy. In 1903, when NAWSA held its convention in New Orleans, Anna Howard Shaw scolded the locals for "putting the ballot into the hands of your black men, thus making them the political superiors of your white women."

None of it worked. Throughout the South, time after time, conservative white men preferred to take the vote away from black men without granting the vote to any women. After ten years of effort, some uncomfortable compromises and some shameful rhetoric, all NAWSA had to show for its southern strategy was an 1898 statute in Louisiana that allowed taxpaying women the right to vote on tax questions.

In 1900, Susan B. Anthony stepped down from NAWSA leadership at the age of eighty. Carrie Chapman Catt became president, with Anna Howard Shaw second in command. The movement languished. Catt and Shaw, both able fundraisers and competent leaders, lacked the charisma and

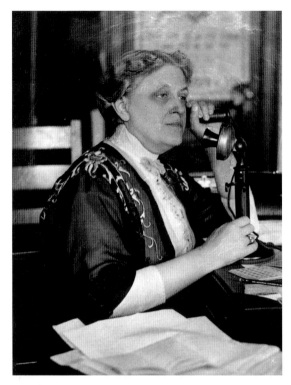

Left: Carrie Chapman Catt.
Library of Congress.

Below: Anna Howard Shaw.
Library of Congress.

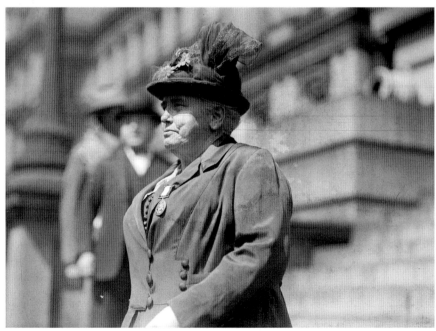

fire-breathing radicalism of Stanton and Anthony. When Harriot Stanton Blatch returned to America in 1902 after years abroad, she snarked that the suffrage movement "bored its adherents and repelled its opponents."

Blatch's observations were particularly acute since she had just been in England, where the suffrage fight was contrastingly vibrant. The British political structure dictated an entirely national strategy, since there was no equivalent to state constitutions. And the parliamentary system meant lobbying individual members was less important than convincing the leadership of each political party to include women's suffrage in their platforms. This required keeping the suffrage issue in the national spotlight; local speeches and regional petition drives were simply ineffective. But constant publicity demands constant, escalating activity. British suffragist Emmeline Pankhurst recognized this need and recognized equally that existing suffrage groups did not have the imagination or will to pull it off. In 1903, she and her daughters Sylvia and Christabel Pankhurst formed the Women's Social and Political Union (WSPU) expressly to engage in more aggressive tactics. And just in case anyone had doubts about the group's intentions, they adopted the slogan "Deeds, not words."

The Pankhursts did not shy away from deeds that would appall even the most radical American suffragists. Christabel in particular was known as a firebrand; she had already gone to jail for spitting in a policeman's face at a Liberal Party event. Her reputation ensured large crowds everywhere she spoke. As the WSPU staged protests, demanded to enter the House of Commons and interrupted political speeches, the British press dubbed them "suffragettes," a patronizing way to distinguish them from the more proper, better-behaved suffragists of the National Union of Women's Suffrage Societies (NUWSS). In a move that would be echoed by "Nasty Women" and "Deplorables" over a century later, the members of the WSPU proudly co-opted the name and were known ever after as suffragettes.

The work of the WSPU began to attract young Americans in England, including Alice Paul and Lucy Burns. Paul moved to England on a graduate school fellowship in 1907. She was captivated by Christabel Pankhurst the first time she heard her speak. Growing up in a Quaker community in New Jersey, Paul had supported equality between sexes in a quiet, intellectual way. She had not worked for the suffrage cause in America as an undergraduate at Swarthmore. But she found the mission of the WSPU compelling. She had no illusions about the radicalism of their tactics. As she wrote to her mother in 1908, "I have joined the 'suffragettes'—the militant party on the woman suffrage question." By then, WSPU members were routinely

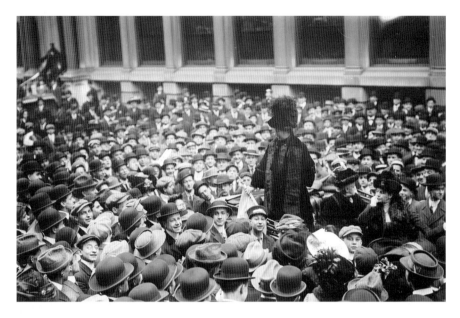

Emmeline Pankhurst addressing a crowd. *Library of Congress.*

arrested and jailed, bringing back harrowing reports of their time in notorious Holloway Prison. As a new, untested member, Paul was initially given small, legal tasks, such as standing on a London sidewalk selling the organization's newspaper *Votes for Women*. She eventually graduated to introducing the more experienced street corner speakers, a steppingstone toward becoming a speaker herself. Public speaking didn't come naturally to Paul, but she overcame her innate shyness and soft voice in service to the cause. She was twenty-four years old.

The cause, by 1908, had narrowed in on opposing all candidates of the Liberal Party. Even pro-suffrage Liberals were targeted. This was Christabel Pankhurst's "Party in Power" strategy, meant to pressure the party leaders to support suffrage or risk losing their majority. And if Liberal suffrage supporters were angry at being on the WSPU hit list, perhaps they would put pressure on their anti-suffrage colleagues. The strategy worked, to a degree. By 1909, a majority in the House of Commons favored a suffrage bill. But Prime Minister H.H. Asquith, a well-known suffrage opponent, blocked a final vote on the bill. He also refused to see any delegations of NUWSS suffragists or WSPU suffragettes. The women seethed but were unable to counter the prime minister's constant, unequivocal opposition. Finally, in June 1909, the WSPU decided the best course of action was to

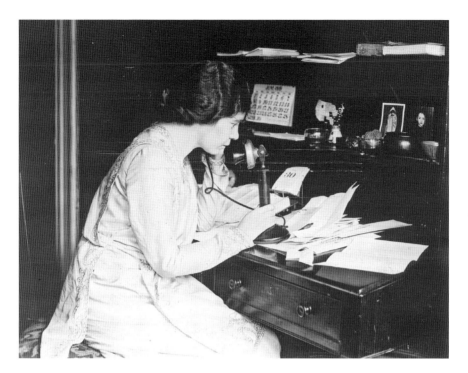

Alice Paul on the phone. *Library of Congress.*

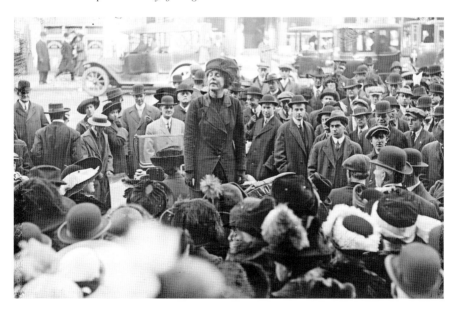

Lucy Burns on the stump. *Library of Congress.*

storm Parliament by force. Alice Paul was invited to join the crowd. This was an escalation of her activities with the suffragettes, which had always been legal, if not always politely received. Forcing her way into Parliament, the WSPU warned, "would probably mean that you were under some danger of being arrested and imprisoned." Paul did not take this warning lightly but ultimately agreed to participate. Some two hundred strong, the women advanced on the Parliament building, Emmeline Pankhurst leading the way. They had been instructed to wear several layers of heavy clothes, despite the summer heat. Three thousand uniformed policemen met them outside the doors. An officer told Pankhurst that Asquith would not see them. She slapped his face and was promptly arrested. The rest of the women then rushed the police lines. Wave after wave of them tried to break through to the Parliament doors. The police spared no force in blocking their way. In a letter home, Paul explained why they were wearing heavy clothes. "The police grabbed the suffragettes by the throats & threw them flat on their backs over & over again. The mounted police rode us down again & again." The women didn't stop. Some threw rocks wrapped in petitions through the windows of government buildings. Finally, the police arrested as many women as they could and brought them to Cannon Row Station.

It was there, sitting on a billiard table, that Paul met Lucy Burns. She noticed Burns's bright red hair and then the little American flag pin in her lapel. Then twenty-nine years old, Burns had been attending graduate school in Germany when she heard the Pankhursts speak on a trip to England. She was so inspired that she dropped out of school and moved to London to work for the WSPU. Burns and Paul had much in common and shared their disappointment in the tepid and ineffective suffrage movement back home.

The two young women now joined the ranks of suffragettes who were arrested more or less routinely. The WSPU protocol for those arrested was to demand political offender status, which had historically been granted to men arrested for political agitation. Political offender status meant the prisoner could wear her own clothes, speak to other prisoners and have pen and paper. This demand was always denied. As a result, the women, dressed in prison uniforms marked with a distinctive "broad arrow," would go on a hunger strike and refuse to eat a bite of prison food. At first, the authorities were stymied by this tactic. They certainly didn't want a suffragette to starve to death, becoming an instant martyr. For a while, they released the women when they began to look pale and sickly, usually after less than a week. But the press coverage of weak, wan women stumbling from the jailhouse was almost as bad as martyrdom. The WSPU took full advantage of the public

British suffragettes outside Parliament. *Library of Congress.*

sympathy, displaying the hunger strikers at suffrage meetings. Their example inspired many, including a young Mohandas Gandhi, who incorporated their methods in his own nonviolent protests.

In late fall 1909, prison authorities announced they would begin force-feeding hunger-striking inmates. On November 9, Paul was arrested for interrupting Prime Minister Asquith at the Lord Mayor's banquet. She was sentenced to a month of hard labor. When she refused to eat, prison matrons held her down while a man pulled her head back by the hair. A doctor pushed a five-foot tube through her nostril into her stomach while Paul screamed. With the tube in place, milk and liquid food were funneled directly into her stomach. This was just as horrible as it sounds. Paul wrote in a letter home, "While the tube is going through the nasal passage it is exceedingly painful & only less so as it is being withdrawn. I never went through it without tears streaming down my face." News of her arrest and force-feeding reached American newspapers. The news coverage was shaded with varying levels of sympathy. Emmeline Pankhurst, never one to let a good publicity opportunity pass her by, happened to be on a speaking tour of the United States. She began to include Paul's plight in her lectures,

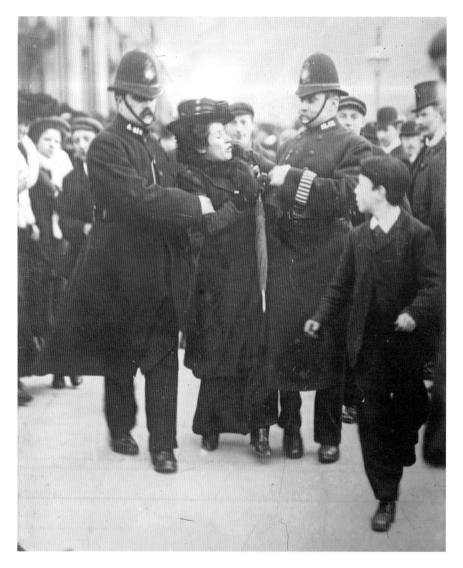

London police arrest a suffragette. *Library of Congress.*

describing her as "a woman whose only offense was proclaiming at a public banquet, 'Votes for women.'" Then she issued her challenge: "What are you American women going to do about it?"

Paul was released on December 9 and booked passage back to America. She arrived on January 20, 1910, and was met by her family and a crowd of reporters. She gave her first interviews while she was still standing on

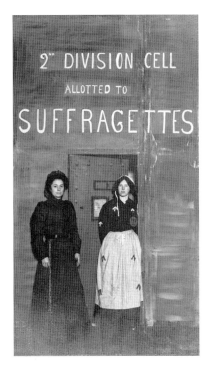

British suffragettes re-create their imprisonment for publicity materials, including the "broad arrow" prison uniform. *Museum of London.*

the dock. When asked about her prison experience, Paul answered that while it was painful and humiliating, "if it ever becomes necessary for me to face it again I shall do so without hesitation."

Local women's rights groups immediately recognized that this suffrage celebrity could invigorate their recruitment and fundraising efforts. They began competing for Paul's time and attention. Harriot Stanton Blatch wanted Paul for her brand-new organization, the Women's Political Union (WPU). NAWSA wanted to book her on a speaking tour. The suffrage association in Ohio wanted her to run its statewide campaign. Without committing to any one group, Paul gave several speeches and helped organize some parades and events, including impromptu street corner talks. She also attempted to restart her abandoned graduate studies.

Both the parades and the open-air speeches were tactics borrowed from the suffragettes. WSPU organizers were experts in designing parades for maximum visual impact. They dictated what women would wear (usually white accented by the WSPU colors of purple and green), how they marched, what their signs said and what music the bands played. They co-opted the symbolic broad arrow from the Holloway prison uniforms and turned it into a protest sign. A well-planned and well-publicized parade could draw tens of thousands of spectators. And it wasn't just the live audience that mattered. In that pre-television era, the visual impact of allegorical tableaux and provocative slogans made all the difference in the next days' newspapers. While suffrage groups had been holding small marches in the United States for decades, they could not compare to the size and scope of the British suffragettes'.

Using the WSPU example, Harriot Stanton Blatch and the WPU planned a grand parade in New York City for May 21, 1910. Instead of following her mother's footsteps and pursuing a leadership role in NAWSA, Blatch

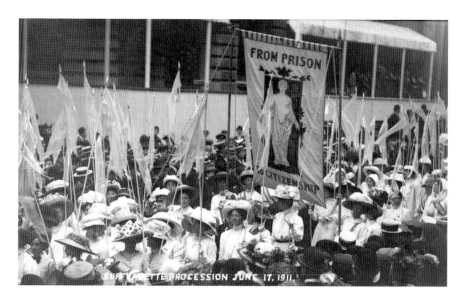

British suffragettes parade upon their release from prison. *Museum of London.*

had concentrated her efforts on passing suffrage in New York State. This was a daunting task, since both houses of the state legislature had to pass a bill authorizing a referendum on suffrage. Then a majority of the state's voters (all male, of course) had to approve it. The two-step process gave anti-suffrage politicians two chances to defeat the measure and demanded twice the work from the suffrage side. Getting the bill introduced and passed required lobbying individual legislators and maneuvering through party conflicts and arcane committee rules. But the popular sentiment to pass the referendum, Blatch reasoned, required public spectacle. As she wrote in the *New York Tribune*, "Men and women are moved by seeing marching groups of people and by hearing music far more than by listening to the most careful argument." The New York suffrage parade would be repeated and expanded annually until women statewide got the vote in 1917.

In 1910, legislators in Washington State, after several fits and starts, succumbed to NAWSA's lobbying and amended their constitution to enfranchise women. It was the first new suffrage state since 1896. Women's suffrage squeaked by in a California referendum in 1911. In 1912, Kansas and Oregon added universal suffrage amendments to their constitutions, and the brand-new state of Arizona passed it by referendum. There were forty-eight U.S. states in 1912, and after sixty-five years of struggle, women could only vote in nine of them.

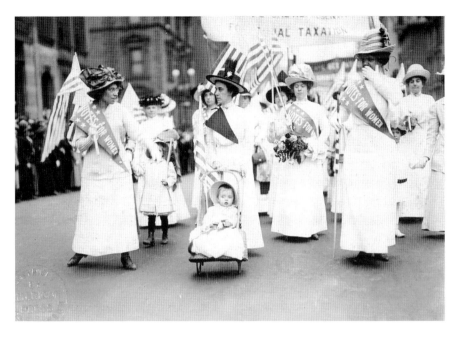

New York City suffrage parade. *Library of Congress.*

From 1910 to 1912, Alice Paul couldn't quite find the right role for herself in the American suffrage movement. She finished her PhD, writing her dissertation on the legal position of Pennsylvanian women. She gave lectures. She helped organize an open-air speech series in Philadelphia. She advised on several different campaigns and events. But there were many more failures than successes, and NAWSA's state-by-state strategy felt exhausting and futile. Some states required constitutional amendments to be passed by two successive legislatures. Some required referenda to pass with a full three-quarters majority of the voters. In some states, legislators only met part time, or only met every other year, or both. Paul wanted to do something that had a bigger impact, to make a difference on a national scale. And then in 1912, Lucy Burns moved back from England, and Paul finally had a like-minded partner.

TACTICAL TRIAL AND ERROR

1913–1916

To Lucy Burns and Alice Paul, it was painfully obvious that NAWSA's conservative, state-by-state strategy was too slow, too polite and too dull to attract the energy the movement sorely lacked. A federal amendment, on the other hand, was immediate, bold and exciting. In December 1912, they asked NAWSA leadership if they could move to Washington, D.C., and resuscitate the flat-lining federal amendment. Carrie Chapman Catt and Anna Howard Shaw were not particularly enthusiastic about the plan. They thought it would pull valuable time, publicity and resources away from the state campaigns. But Harriot Stanton Blatch, with a timely assist from the nationally famous Jane Addams, convinced them to let the younger women have their shot. It helped that Burns and Paul were willing to work for free. Shaw officially appointed Paul chairman of NAWSA's Congressional Committee, with Burns as vice chair.

The Congressional Committee assignment came with an annual budget of exactly ten dollars. Since the committee's only task was to make sure the Susan B. Anthony Amendment was introduced in every Congress, outgoing chairman Elizabeth Kent usually spent a little money on postage and other small expenses and returned the change to NAWSA's treasury. Paul and Burns made it clear that they planned to greatly expand the size and scope of the Congressional Committee and were given permission to do so on the condition that they raise all their own funds. NAWSA leadership did dip into its pockets deeply enough to provide a list of suffrage supporters in D.C. who might prove useful. This gesture was less

generous than it might have been, as most of the women on the list had the disadvantage of being dead. Paul was, therefore, delightfully surprised by the enthusiastic support of Emma Gillett (Paul later described her as "friendly and interested," as well as "still living") and Belva Lockwood, two of the four female practicing attorneys in the capital. Gillett helped find a cheap basement office space at 1420 F Street NW. Elizabeth Kent offered to help subsidize the sixty-dollar monthly rent.

With an office, some friends and the grudging blessing of the NAWSA leadership, Paul could finally get to work on the plan she had in mind all along: a huge, splashy parade to announce the revival of the push for a federal amendment to a national audience. In December 1912, Paul called on Police Superintendent Richard Sylvester to secure two essential details. First, she wanted the date of March 3, 1913, the day before Woodrow Wilson's inauguration. And second, she wanted a permit to march straight down Pennsylvania Avenue, from the Capitol to the White House, and then a block beyond to Continental Hall (now Constitution Hall). Sylvester's reaction was somewhat short of pleased. His police force was not huge, and back-to-back suffrage and inaugural parades would stretch

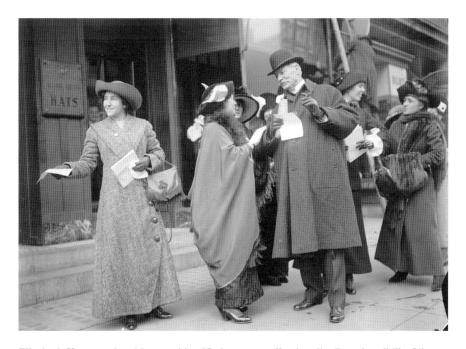

Elizabeth Kent speaks with an unidentified man as suffragists distribute handbills. *Library of Congress.*

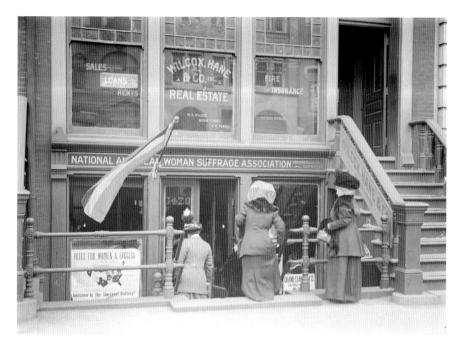

NAWSA Congressional Committee Headquarters at 1420 F Street NW. *Library of Congress.*

his overworked force dangerously thin. And Pennsylvania Avenue was far too close to the most crowded of the city's saloons. Large crowds plus ready booze minus an adequate police presence equaled potential disaster by Sylvester's calculation.

Paul would not budge on either requirement. She knew the symbolic power of upstaging Wilson's inaugural parade. Near the end of December, Sylvester agreed to the March 3 date. But he would not permit Pennsylvania Avenue. To be fair, he offered alternatives: how about marching down the tree-lined and stately Sixteenth Street? It was wider than Pennsylvania Avenue and much more residential. A parade down Sixteenth Street would look beautiful, stay safe and still be able to end at the White House. Paul held firm. She didn't want beautiful and safe. She wanted the symbolism of marching where men marched, where important national celebrations took place. She wanted the message that women were taking the suffrage campaign to the center of federal power and holding national officeholders accountable. Pennsylvania Avenue was the setting for many grand parades; armies had marched there in triumph since the avenue was first paved. But no one had ever claimed the street for a protest march like this one.

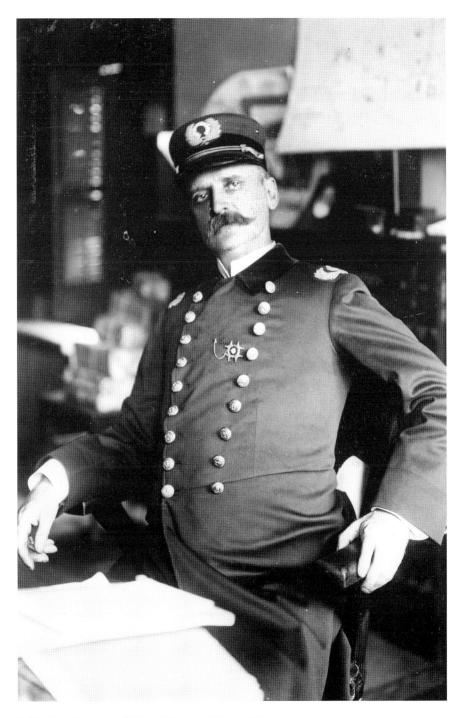

Police Superintendent Richard Sylvester. *Library of Congress.*

Every iteration of a march on Washington since then has built on this same idea—bringing a cause directly to the men (and later women) who could do something about it. But Alice Paul was the first. And if Sylvester wasn't going to give her Pennsylvania Avenue, she'd find someone who would. She went over Sylvester's head to John Johnston, the city commissioner who oversaw the police department. She took her fight public, resulting in a *Washington Times* editorial that stated, as Paul crowed to the NAWSA leadership, "that there is no reason why we should not have that particular street, since men's processions have already marched there."

The good news was that Sylvester finally caved and approved the permit for Pennsylvania Avenue. The bad news was that he waited until January 9, 1913, to do so, leaving Paul and her fledgling committee less than two months to fund, plan, publicize and execute an event of unprecedented scope with the future of the suffrage movement at stake.

By then the Congressional Committee had five official members. Lucy Burns recruited Crystal Eastman, a friend of hers from Vassar who had become a prominent socialist and advocate. Historian Mary Beard, who had worked with striking female garment workers, joined her. And breaking the young firebrand mold was Dora Lewis, a prominent Philadelphia widow who was so impressed with Burns and Paul that she risked her long friendship with Anna Howard Shaw to join the new movement in Washington. They were few in number but formidable in education, determination, imagination and strength of will. They hung portraits of movement patron saints Susan B. Anthony, Elizabeth Cady Stanton and Lucy Stone in the F Street headquarters and got to work. Together, the five women cajoled everyone they knew into helping with the parade. By the middle of January, Paul's letterhead was jam-packed with names forming the "Joint Inaugural Procession Committee," as well as D.C. suffrage societies and local influential supporters. Stories abounded of curious tourists being pulled into the F Street office to lick envelopes or contribute money.

The organizers of the Great Suffrage Parade had several goals for several different audiences. For the NAWSA leadership and suffrage supporters, the parade was meant to announce a renewed effort to pass the federal amendment and a shift of focus from New York to Washington, D.C. For the incoming Wilson administration, the parade was an opening move, calculated to show the anti-suffrage president the force of the foe he would be facing. And for the general public, both on the streets of D.C. and around the country, the parade had to show that despite only middling success over sixty-five years, the suffrage movement was far from dead. It

Right: Dora Lewis. *Library of Congress.*

Below: *Left to right*: Elizabeth Kent, Lucy Burns, Mary Beard, Crystal Eastman and an unidentified woman near the Congressional Committee Headquarters. *Library of Congress.*

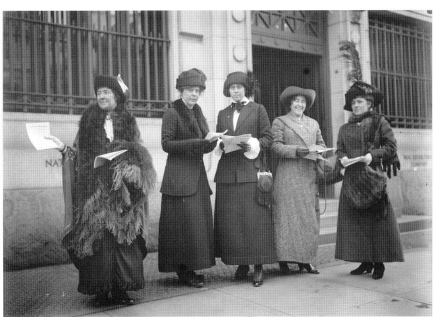

was a lot to ask from one event, no matter how many floats and bands it included. And expectations were high. The 1913 NAWSA Annual Report promised it would be "the most elaborate pageant procession the country had ever known."

Impressing NAWSA leadership was no small task. Despite allowing Paul and Burns to resurrect the Congressional Committee and plan the parade, Shaw was dubious that the odds of passing a federal amendment were good enough to bet time and treasure. And she was equally unconvinced that Paul and Burns were the right women for the job. While she appreciated the publicity the Pankhurst protégés brought to the cause, she and other NAWSA leaders were terrified that they would degrade the American movement with the more violent tactics of the suffragettes. There was a whole subtext to the March 3 event that was meant to contrast the virtuous American suffragists with their smashmouth British counterparts. As pageant director Percy MacKaye wrote, "At the capital of the British Empire, women have been smashing windows, scattering flames and acid: at the capital of the United States, women have been building pageants, scattering the creative fires of beauty and reason."

Paul's leadership was tested by a few issues she hadn't anticipated, of varying levels of importance. An anti-suffrage group set up offices nearby, and male reporters delighted in writing stories suggesting the two groups were engaging in catfights. Rumors circulated that NAWSA was paying "pretty girls" two dollars to march, while the antis were paying them three dollars to stay home. Paul largely ignored them. The *Washington Post* reported that college students were planning to release mice along the parade route. Paul dismissed them. Then a woman named Mrs. Clifford asked Paul if black women would be welcome to march. Alice agreed, hoping she could keep this information out of the papers. Then NAACP leader Mary Church Terrell and the Delta Sigma Theta sorority from Howard University asked to join the college section, and Paul began to get nervous. NAWSA leadership was unequivocal. The suffrage movement advocated enfranchising all American women, they reminded Paul, and could not exclude black women. But Paul was hearing from state organizers that some white marchers would refuse to participate in an integrated parade. Journalist Ida B. Wells, founder of the Alpha Suffrage Club for black women, asked to participate. Paul floated the idea of a discrete African American group, near the back of the parade. In the end, Wells waited with the spectators and then emerged from the crowd to march where she wanted to, with the Illinois

delegation, and the participation of black women did not cause the crisis Paul feared it would. But Paul's mismanagement of the issue highlighted how inexperienced she really was.

The goal of impressing President Wilson was also daunting. Wilson had been evasive on suffrage throughout the 1912 campaign. The issue wasn't even really discussed until Theodore Roosevelt, stung by losing the Republican nomination to William Howard Taft, ran as a candidate of the Progressive Party, which included a universal suffrage plank in its party platform. Wilson's Democratic Party, by contrast, took no position on suffrage. When asked about it on the campaign trail, Wilson said he preferred not "to bring the woman suffrage question into the national campaign." Wilson had made several patronizing comments in public and in private that indicated he found women in any public roles to be distasteful and annoying, but for the purposes of the 1912 campaign, he cloaked his misogynist views in the mantle of states' rights. He told a suffragist at one campaign event, "Woman suffrage, madam, is not a question that is

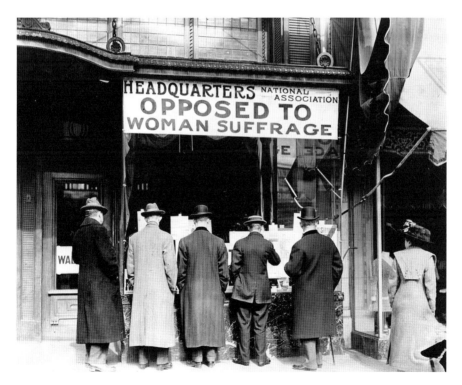

Men read broadsides in the window of anti-suffrage headquarters. *Library of Congress.*

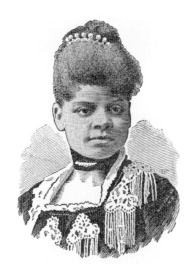

Ida B. Wells. *Library of Congress.*

dealt with by the National Government at all. I am here only as a representative of the national party." This massive parade on the day Wilson arrived in the capital had to announce that his national government would be required to deal with suffrage, no matter how the issue and its champions irritated him. The president certainly took notice of the fact that the parade stole some of his inaugural thunder, but the issue would not be resolved on his first day in town. The march could only ever be an opening volley in a protracted battle. The suffragists would spar with Wilson many, many more times over the next seven years.

As for the opinion of the general public, Paul and the rest of the Congressional Committee did everything they could to ensure positive publicity. They strategically released details of the march throughout February, teasing the public with stories of striking costumes and exotic floats. The *Washington Post* ran articles almost daily, culminating with a breathless account on March 3 headlined "5,000 of Fair Sex Ready to Parade," with no fewer than four subheads, including "Famous Leaders in Charge" and "Floats, Bands, Skirted Calvary and Beauties Take Part."

But it was the near riot during the parade that swung even skeptical newspapers to the suffrage cause. Paul and Burns recognized the sympathetic publicity value of the rude crowd and useless policemen immediately. As dejected marcher Mary Foster would later write, "To our great surprise, these leaders were jubilant! We learned that what happened was not a catastrophe, but an unlooked for blessing. It would promote the cause of suffrage far more than any beautiful parade could do." Paul milked the moment for all it was worth. She even hinted, with no evidence, that unnamed powerful forces actually intended to thwart the marchers. In a *Washington Post* interview, she claimed, "There is no question that the police had a tip from some power higher up to let the rough characters in the city through the police lines try to break up our parade." She asked women to submit notarized depositions before they left town, detailing their mistreatment at the hands of spectators and police. Congressional Committee publicists then used those depositions

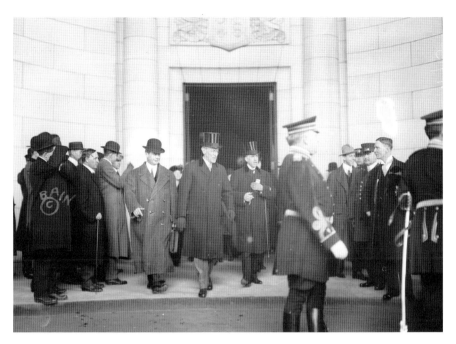

President Woodrow Wilson arriving at Union Station, Washington. *Library of Congress.*

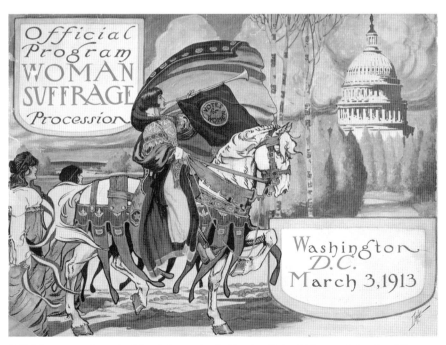

Official program from the March 3 parade. *Smithsonian National Museum of American History.*

to write press releases targeted to the women's hometown newspapers. The coverage of *Fort Wayne Sentinel* was just one example of many. "Police Must Face Charges," its headline ran. "Failed to Protect Suffrage Parade Against Hoodlums. Scene Was Shameful." Even the anti-suffrage *New York Times* reported the day was an "insult to American womanhood and a disgrace to the Capitol City of the Nation." On March 4, Harriot Stanton Blatch sent a telegram to President Wilson and helpfully sent copies to the newspapers: "As you ride today in comfort and safety to the Capitol to be inaugurated as President of the people of the United States, we beg that you will not be unmindful that yesterday the Government which is supposed to exist for the good of all, left women while passing in peaceful procession in the demand for political freedom at the mercy of a howling mob on the very streets which are being at this moment efficiently officered for the protection of men." The press bulletins and interviews also stressed the stalwart perseverance of the suffragists. These brave women, despite unruly and ill-behaved men, marched steadfastly on, propelled by their sense of justice and righteousness.

Paul had to tread a thin line with respect to the crowd. She didn't want to create the impression that suffrage was unpopular. The inaugural crowd on March 4 behaved beautifully. So she shifted her focus to concentrate on the behavior of the police, accusing them not of failing to control the crowd but of actively encouraging hostility. She began to press for a congressional investigation into the police force's responsibility for the disorder. A Senate subcommittee was appointed to take testimony on March 5 and began hearing witnesses on the afternoon of March 6. The testimony continued for another two weeks. "The hearing promises to be one of the most sensational conducted at the Capitol in years," predicted the *Washington Post*. For the rest of March, the issue of suffrage was rarely out of the news. And the movement gained adherents and enthusiasm every day. As Illinois congressman Clyde Tavenner wrote, "More votes were made for women suffrage in the city of Washington on the afternoon of March 3rd than will perhaps ever be made again in the same length of time so long as the government stands." And although the Senate committee ultimately exonerated Police Chief Sylvester of malicious intent, he was chastised for not providing adequate crowd control, and court of public opinion judged him harshly.

If the March 3 parade was the opening move in a new match to convince the Wilson administration to pay attention, Paul knew she couldn't wait too long to follow it up. So while the Senate investigation continued, Paul organized what would be the first of many delegations to see the new president. On March 17, Paul, NAWSA historian Ida Husted Harper and

Genevieve Stone, a congressman's wife who had been assaulted in the parade, went to the White House to ask President Wilson about his views on suffrage. It's not clear why Wilson didn't answer honestly about his antipathy to suffrage or even why he didn't revert to his states' rights argument. Instead, he gave the frankly lame response that he had no opinion on suffrage, he had never given the matter much thought and he didn't know enough about it to take a position. Besides, he was far too consumed by currency revision and tariff reform to fuss with the suffrage question.

He might as well have double-dog-dared Alice Paul to make him care about her and her movement. Paul sent two more delegations to Wilson in March 1913 alone. When he started ducking the meetings, the women would show up and wait, usually accompanied by reporters. On April 3, Senator Joseph Bristow of Kansas and Representative Frank Mondell of Wyoming introduced the federal suffrage amendment. Alice Paul marked the occasion by arranging for 531 women (one for every member of Congress) to march to the Capitol with petitions in support of the amendment. Now referred to as the Bristow-Mondell Amendment, it read, in its entirety:

> *The right of citizens of the United States to vote shall not be denied or abridged by the United States or any State on account of sex.*
> *Congress shall have power to enforce this article by appropriate legislation.*

The bill was promptly sent to the recently revived Woman Suffrage Committee, a move Paul and Burns considered a victory. Paul began planning more demonstrations for the summer of 1913 calling for the amendment's passage.

At first, Anna Howard Shaw and the NAWSA leadership were delighted by the success of the Congressional Committee. After the march, Shaw wrote to Paul, "Too much credit cannot be given to you and Miss Burns and the others who are responsible for all this." But as Alice Paul continued to dominate suffrage news in the spring of 1913, Shaw began to feel left behind. At first her chastisements were gentle. In late March, Shaw wrote to Paul and Burns, "I do not want you to feel for a moment that we are finding fault, only we feel if there could be consultation we could work together and know what each is doing." Paul seems to have entirely ignored this request, for in April she surprised NAWSA leadership by announcing the formation of the Congressional Union (CU), a NAWSA subsidiary for women in each state who wanted to focus on passing the federal amendment. The Congressional Committee would restyle itself as the executive committee of this new

organization. Shaw bristled. She sent word that in NAWSA's view, the Congressional Committee shouldn't "have anything official" to do with the new offshoot. In May, Paul told Shaw she planned to start a new publication, called *The Suffragist*, to keep women up to date on the progress of the federal amendment. Shaw was concerned it would compete with NAWSA's *Woman's Journal* and urged Paul to bring the idea to the board meeting in September for approval. Again, Paul ignored her. Blithely assuring Shaw that she was not planning a "journal" but simply a "weekly bulletin," Paul went right ahead with her plans.

Underlying Shaw's hesitation was the concern that Paul and Burns, if given free rein, would make use of the suffragettes' more militant tactics. The Pankhursts and their followers had escalated their activity that summer, cutting telephone wires and setting fires in London and even exploding a bomb in the partially completed home of Chancellor of the Exchequer Lloyd George. Shaw's concern was not unfounded. When Emmeline Pankhurst visited the United States in the fall of 1913, Paul and Burns arranged fundraisers for her, despite Shaw's public disapproval. In November, Burns wrote "Votes for Women" in chalk on a New Jersey sidewalk, where it was apparently illegal. Burns wasn't arrested, but breathless reporters asked her if the sidewalk-chalking incident was a herald of more militant tactics à la Pankhurst. Burns laughed that it was simply "a form of economical advertising." Shaw was not amused. She admonished Burns to behave herself. "It requires a good deal more courage to work steadily and steadfastly for forty or fifty years to gain an end," she wrote, "than it does to do a impulsive rash thing and lose it." When the first issue of *The Suffragist* was published in November, the debut issue featured an unflattering caricature of President Wilson. Shaw was appalled.

In addition, Paul, who had been told to raise her own funds for the federal campaign, encouraged NAWSA donors who supported a federal strategy to redirect their funds to the CU. In Shaw's view, Paul had already poached Dora Lewis and Crystal Eastman, and now she was going after the NAWSA treasury. It was the last straw. At the annual NAWSA convention in December, all talk was about Paul and Burns and what the Congressional Committee had accomplished. It is true that Shaw resented sharing the limelight with her young colleagues. But it is equally true that she genuinely worried that Paul and Burns would damage the success of the movement. "In all my experience in suffrage work," she wrote to a friend, "I have never known such determination on the part of 2 or 3 women, who really wish to ruin the association, as has been manifested by the leaders of the Congressional

union." At the convention, NAWSA officers told Paul that the CU could only remain affiliated with them if she gave up control of her finances and decisions. Paul refused. By January 1914, Paul and Burns were out. They were told to give up all their files to a new Congressional Committee and to ensure that the CU had absolutely no affiliation with NAWSA.

Burns and Paul and the CU were now autonomous, but they had made enemies of Shaw and NAWSA. They did, however, win one key friend. Alva Belmont was an enormously rich and influential New Yorker who felt underappreciated by NAWSA. By February, the *Washington Post* was reporting, "The executive committee of the union was entertained at tea by Mrs. O.H.P. Belmont, of New York, a newly elected member of the executive committee of the union." Belmont would become a trusted advisor and the CU's biggest financial supporter. Others stayed with Burns and Paul after the split. The ever-loyal Elizabeth Kent hosted a CU fundraiser in her home in January 1914, and it was there Paul revealed exactly how radical an independent CU could be. It was time, Paul announced, to hold the entire Democratic Party, as the party in power, responsible for passing a federal amendment. The CU would, therefore, oppose all Democratic candidates in states where women could vote in the 1914 election, regardless of their position on suffrage. Paul reasoned that all Republicans in suffrage states were pro-suffrage, so the movement wouldn't suffer a net loss of supporters nationally, and the strategy might send a message to Democratic candidates in states where women couldn't vote. This "party in power" strategy was borrowed entirely from Christabel Pankhurst's campaign to defeat the British Liberal Party. The *Washington Post* trumpeted the news with the somewhat wordy headline "Out With the Party that Fails to Give Vote to Women Is the Plan of 'Militant' Suffragists." CU spokesman Mary Beard insisted in the same article that the "militant" tag was unjust. "We have had parades, meetings, debates, deputations to the President, but not one single militant act can be laid at the door of the suffrage party." To the NAWSA leadership, this party-in-power strategy confirmed all their worst fears about Paul and Burns. Opposing sympathetic Democrats was "suicide for the suffrage movement," the re-formed Congressional Committee declared, and NAWSA would launch "a countermovement on the part of thousands of women in our organization who will go to the support of such men." The undermining tactics of NAWSA didn't stop there. They denounced Paul and Burns to their membership. When the CU held a fundraising ball in Washington, Congressional Committee chair Ruth McCormick urged her society friends not to participate. Alva Belmont took over the ball and

encouraged *her* society friends to support it. The ball was a success. NAWSA also criticized the CU in the press, publishing patronizing editorials in sympathetic newspapers.

But the real threat came in the spring of 1914, when NAWSA tried not only to destroy the CU but also, somewhat self-destructively, to torpedo the chance of a federal amendment. On March 2, Senator John Franklin Shafroth of Colorado introduced an amendment that had been drafted by Ruth McCormick. The Shafroth-Palmer Amendment required that if 8 percent of the electorate of any state petitioned to hold a suffrage referendum, the state must do so. It was NAWSA's state-by-state strategy encoded into law. Supporters claimed states that wanted to give women the vote would have an easier path. They also liked that it provided cover for pro-suffrage members of Congress who opposed a federal amendment on states' rights grounds. But it was a complicated concept that took some time and effort to appreciate, even for McCormick, who said, "It reminds me a good deal of the first time you taste an olive." Paul and the CU vowed to kill it. She wrote in *The Suffragist*, "It is a little difficult to treat with seriousness an equivocating, evasive, childish substitute for the simple and dignified suffrage amendment now before Congress."

On March 19, NAWSA pressed Senator Charles Thomas, chairman of the Woman Suffrage Committee, to schedule a vote on the Bristow-Mondell Amendment (the temporary name of the once and future Susan B. Anthony Amendment). Paul begged him not to, knowing the amendment didn't yet have the votes to produce a two-thirds majority and that a failed vote would effectively kill the amendment for that Congress. This would be only the second time the amendment came up for a Senate vote and the first vote in the twentieth century. Paul desperately wanted time to ensure a good showing, if not outright victory. Thomas scheduled the vote anyway, and the results came in at 35 in favor, 34 against. It was a big improvement over 1887 but still well short of victory. The next day, a disappointed Paul wrote to a friend, "We knew and every member of the Senate knew that it would be lost if voted on yesterday. The Congressional committee, however, insisted upon such action and by this demand of theirs gave the Democratic leaders the opportunity of killing the bill and seeming, at the same moment, to be following the wishes of suffragists." Senator Bristow reintroduced his amendment on March 18, and thereafter, its supporters were careful to call it "the Susan B. Anthony Amendment" in contrast to Shafroth-Palmer.

As Shaw had predicted, *The Suffragist* became much more than a "weekly bulletin." The CU hired Pankhurst biographer Rheta Childe Dorr as editor,

Left: Alva Belmont. *Library of Congress.*

Below: Congressional Union volunteers posting a notice for the May 1914 event. *Library of Congress.*

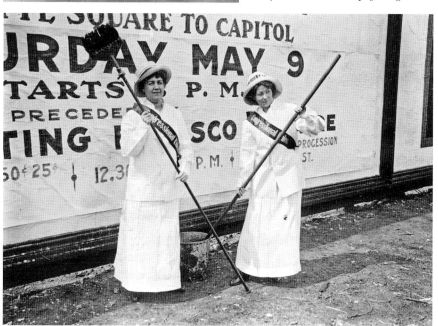

but the real voice of the paper came from Alice Paul. In April 1914, Paul locked Dorr out of her office while she rewrote the editorial page. Dorr resigned on the spot. Paul shrugged. She was going to need total control of *The Suffragist* for her next big move.

If the March 1913 parade was meant to bring the suffrage issue to Washington, the May 1914 event brought it to every town in America. On May 2, coast-to-coast demonstrations were planned to show the breadth and depth of support for suffrage. From Chicago to New Hampshire to New Orleans to Cheyenne, thousands and thousands of women marched, spoke, met and organized. "Never again will it be possible in the United States," declared *The Suffragist*, "for anyone to declare that the great mass of women do not want to vote." A week later on May 9, a parade in Washington reminded all those supporters of the primary goal: a federal amendment. This time, the police made a big show of providing protection all along the parade route. But this march was not merely pageantry; women from every congressional district carried resolutions demanding a federal amendment. NAWSA even contributed a float supporting the Shafroth-Palmer Amendment. Paul included them not to make peace but to show to all involved how small and naïve NAWSA's efforts were compared to this massive, elegant, national movement.

As the 1914 elections loomed, Paul and Burns started plotting the specifics of their party-in-power strategy. Alva Belmont invited the CU advisory council to her Newport, Rhode Island "cottage" in August to kick off the campaign season. They knew their limited funds and membership could only accomplish so much, but perhaps this election could be seen as a dress rehearsal. "By 1916 we will have it organized," Paul claimed. They identified enough organizers to cover the nine suffrage states, with emphasis on the more Democratic California, Colorado, Kansas, Oregon, Washington and Arizona. Heavily Republican Utah, Wyoming and Idaho were less of a priority. The organizers set out from Washington's Union Station on September 14, 1914. They traveled with banners (for display on theoretical local headquarters), posters, membership cards, copies of *The Suffragist* and ten small pennants. They were also each given a state map, a list of local newspapers and instructions to report weekly. Each hoped to plug into local suffrage networks in their assigned states and take advantage of existing connections and support. But no such networks existed. In states where women had the vote, suffrage organizations weren't necessary. Jane Pincus reported from Arizona that the locals "aren't particularly interested here in suffrage, they didn't have to work for it." A disheartened Gertrude Hunter

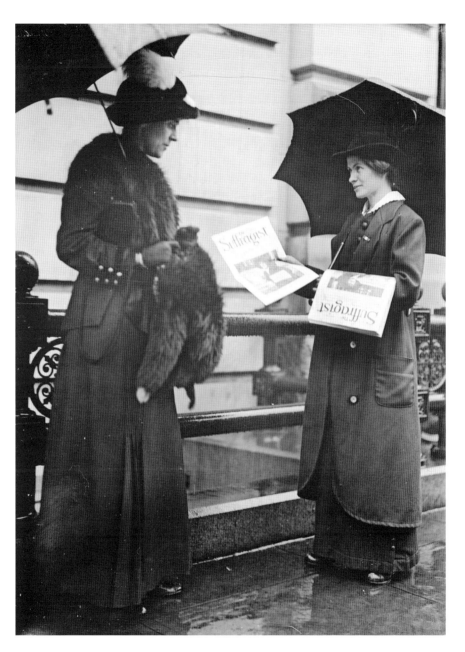

Selling copies of *The Suffragist. Library of Congress.*

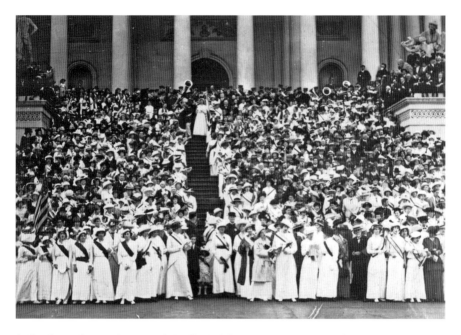

Suffragists gather on the steps of the Capitol, May 9, 1914. *Library of Congress.*

lamented from Wyoming, "It is very hard to keep enough courage from one day to another, to work against this blank wall of indifference which is so much more killing than opposition." The organizers also found widespread enthusiastic support for President Wilson. Voters were delighted that he was keeping the United States out of the growing European conflict. And he had been widowed a few weeks earlier, making him a very sympathetic figure even to his opponents. Doris Stevens warned from Colorado, "The air here is full of hero worship of Wilson and so is the press." Their campaign was unsuccessful. The vast majority of the Democrats the CU opposed were reelected, and the Democrats even gained three seats overall. NAWSA could claim no better success: suffrage had passed in Nevada and Montana but lost in Nebraska, Missouri, Ohio and the Dakotas. Suffragists across the nation licked their wounds and vowed to fight on.

On January 12, 1915, the House of Representatives scheduled its first-ever vote on the Susan B. Anthony Amendment. No one expected it to pass. But CU and NAWSA members desperately wanted to hear the debate and identify supporters, opponents and key arguments. Alice Paul was there, as was Anna Howard Shaw. The usual states' rights objections were raised, as well as doubt that women were worthy of the sacred franchise. Some of the

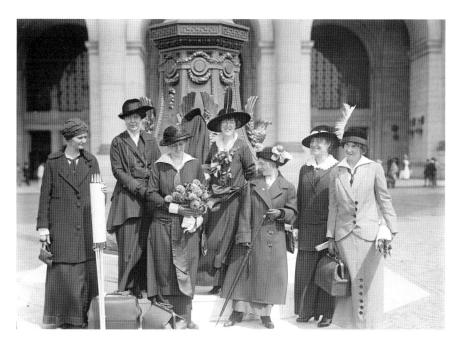

Above: Setting off on the 1914 campaign trail, Union Station. *Library of Congress.*

Right: The "party in power" strategy in action. *Library of Congress.*

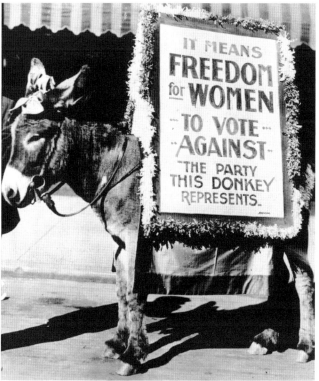

testimony was frankly nonsensical. "The women of this smart capital are beautiful," rambled Stanley Bowdle of Ohio. "Their beauty is disturbing to business; their feet are beautiful; their ankles are beautiful, but here I must pause—for they are not interested in the state." The suffragists in the galleries booed him until the Speaker gaveled for silence. The amendment went down 204–174.

After the election losses of 1914, Paul decided her time was best spent raising money. She hit the road in the spring of 1915, leaving Burns in charge of the CU and *The Suffragist*. Paul was, by all accounts, a formidable fundraiser. She came to realize that people were most likely to give money for immediate, definable needs. For instance, in February 1915, she told one national organizer not to spend scarce money on a telephone but instead to make a big production of using a public call box. When local supporters saw she was "greatly inconvenienced by the lack of a phone, it is quite likely that a great many people would be willing to each give a dollar." Paul also decided the time was right to shift some focus away from Washington. The usual parades and demonstrations were becoming routine, and if the CU wanted to stay in the newspapers, it needed a new stunt. The Panama-Pacific International Exposition was coming up in San Francisco, and the CU would be there front and center—literally. The CU booth was in the Palace of Education and Social Economy, the first building visitors saw as they entered the main gates. With its comfortable chairs and sofas, the CU booth attracted four hundred visitors a day under the "great demand" banner in party colors reading, "We demand an amendment to the United States Constitution enfranchising women." Many of those visitors stayed to pay CU dues or subscribe to *The Suffragist*. They also signed a petition calling for a federal amendment. As the pages of signatures piled up, Paul decided she needed a spectacular way to deliver the dramatic petition to Congress. On September 16, the last day of the Expo, Paul planned a huge event in the aptly named Court of Abundance. The crowd of ten thousand supporters formally pledged their allegiance to the Susan B. Anthony Amendment. They sang "The Women's Hymn," which included the lyrics "Firm in reliance, laugh a defiance, (Laugh in hope, for sure is the end). March, march—many as one, shoulder to shoulder and friend to friend." Then they loaded the petition and all its signatures into a shiny new Overland touring car dubbed the Suffrage Flyer. The car belonged to Maria Kindberg and Ingebord Kindsteadt, two capable if slightly peculiar Swedes who planned to drive cross-country and offered to take the petition with them. Paul convinced Sara Bard Field and Frances Joliffe to act as "envoys"

to accompany the Swedes and the petition in a well-publicized suffrage tour across the nation. They were, of course, to send regular dispatches back to Lucy Burns for publication. Mabel Vernon would travel ahead of them and arrange lodging and speaking gigs.

Joliffe only made it to Sacramento before she dropped out. Field hung in there through mud and rain and mechanical failure. They got lost more times than they could count. Somewhere around Ohio, Field realized that her press coverage was promising a three-mile-long petition with 500,000 signatures. She estimated the actual number of signatures at closer to 4,000. She and Vernon were told to start collecting signatures immediately everywhere they went. As the Overland neared the East Coast, winter set in, and the car was often snowbound or freezing or both. Field threatened to quit several times, and Paul always talked her off the ledge. Bad news rolled in. In November, state suffrage referenda failed in New York, New Jersey, Pennsylvania and Massachusetts. Anna Howard Shaw was replaced by Carrie Chapman Catt, who was, if anything, more hostile to the CU. Paul desperately needed the presentation of the petition to go smoothly. But the

Visitors enjoy the CU booth at the Pan Pacific International Exposition. *National Woman's Party at the Belmont-Paul Women's Equality National Monument, Washington, D.C.*

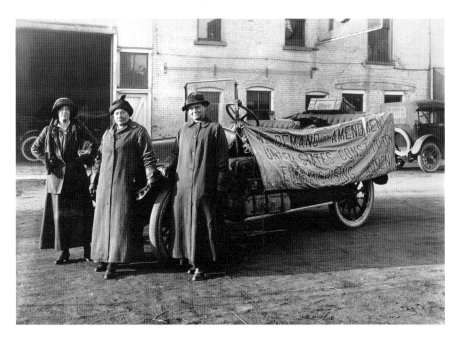

The Suffragist Flyer sets off from San Francisco. *Library of Congress.*

giant promised petition didn't exist. "When the press began making a big deal of it, and the necessity for presenting something voluminous to Congress appeared," wrote Field, "we all became anxious about the petition and have tried to secure as many names as possible." But they couldn't possibly live up to the outsized expectations. Paul solved the problem by leaking to the *Washington Post* that the petition had been lost. They had mailed the petition the last few miles, Paul explained, and the shipping company misplaced it. Happily, they had a more modest yet still impressive one-hundred-foot-long petition with some 10,000 names, which was unfurled on the steps of the Capitol on December 6 ,1915, opening day of the Sixty-Fourth Congress.

As 1915 drew to a close, Paul rejoined the CU in Washington in its new headquarters. Cameron House was on Lafayette Square, directly behind the White House. The yellow mansion signaled stability and prosperity for the CU, a huge improvement from the basement quarters on F Street. Paul and Belmont decided it was time to reintroduce themselves to their presidential neighbor and arranged a meeting at the White House. When the suffrage referendum was pending in his home state of New Jersey, the newly remarried Wilson had surprised many by declaring he would vote for it. He wasn't opposed to women's suffrage, he said; he just wanted to leave the issue

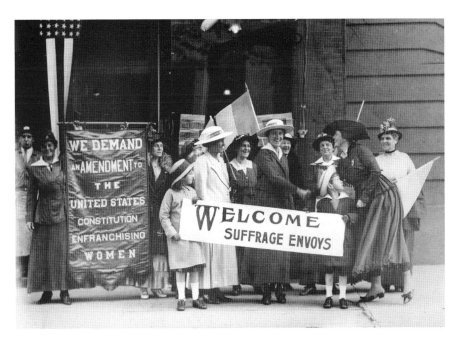

The Suffrage Flyer envoys make their way across the country. *Library of Congress.*

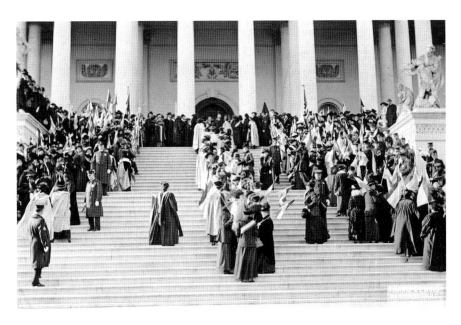

Unfurling the petition on the steps of the Capitol, 1915. *Library of Congress.*

up to the states. Paul was skeptical. She wrote in an editorial, "In Congress, where chances for the success of woman suffrage were good, he turned his whole party machine against it; in New Jersey, where defeat was sure, he cast a solitary vote in its favor." Now Paul and Belmont pushed Wilson to take a stand nationally and to be a progressive leader on the suffrage issue. Wilson insisted he couldn't include suffrage in his annual address to Congress, as the text of his speech had already been released to the newspapers—a speech that now emphasized war preparedness above all else. But he did say, "I hope I shall always have an open mind." The suffragists took this as progress. But if his words turned out to be empty, Paul planned to take what she had learned in the 1914 campaign to hold him and the Democrats accountable in 1916. In the meantime, as the war in Europe dominated headlines, she needed to keep suffrage in the news.

In April 1916, the CU launched the Suffrage Special, a national train tour of twenty-three prominent suffragists led by Lucy Burns. Harriot Stanton Blatch and Inez Milholland (the "most beautiful suffragist" from the 1913 parade) headlined as speakers. Over thirty-eight days, the train wended its well-planned way from east to west, meeting crowds and excellent press coverage wherever it stopped. The *Seattle Post Intelligencer* gushed, "The wise

Congressional Union headquarters at Cameron House, Lafayette Square. *Library of Congress.*

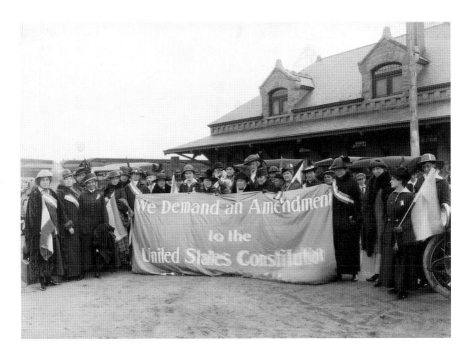

The Suffrage Special arrives in Colorado, 1916. *Library of Congress.*

men followed the star in the east. For the wise woman gleams a ray of hope in the west and today comes out of the east a band of women to hitch their suffrage wagons to the western star."

Meanwhile, Paul was pondering the 1916 election. She decided it wasn't enough to oppose the Democratic Party; the time had come for suffragists to form a party of their own. Their party platform would contain a single plank: passage of the federal amendment. Paul chose Chicago to announce the debut of the National Woman's Party (NWP). Some states now allowed women to vote in school or municipal elections but not state or federal ones. Illinois women, by contrast, were allowed to vote for president but not for other offices or issues. So the women of Illinois, along with those of the nine universal suffrage states, could be the only members of the new party. Pretty much the whole CU leadership, easterners almost to a woman, could not join the party they founded. The NWP rejoiced when the Republican presidential candidate, Charles Evans Hughes, announced he supported suffrage: "My view is that the proposed amendment should be submitted and ratified, and the subject removed from political discussion." But Hughes proved a disappointing champion, as he largely ignored the issue and put no pressure on his party to include it in the platform. His support, he argued,

was "purely a personal opinion." The Democrats, of course, would still not consider federal suffrage. Their platform plank, which most agreed was written by Wilson himself, recommended action by individual states. And Wilson was looking more and more unbeatable. Running on the slogan "He Kept Us Out of War," Wilson was enjoying an almost heroic reputation. At a Wilson campaign event in Chicago in October, NWP members silently appeared with banners. "President Wilson! Why do you seek votes from women when you oppose votes for women?" read one banner. "Why did President Wilson oppose woman suffrage in Congress, where he had great power, and vote for it in New Jersey, where he knew it would fail?" asked another. The crowd turned on the women. They ripped the banners from their hands and snapped the poles in half. The *Chicago Tribune* reported, "Those who attempted to defend their banners were beaten on the knuckles till their grip relaxed." Wilson did not comment.

On the campaign trail in California, Inez Milholland was proving to be a superstar. She packed houses wherever she spoke. So when she started to feel sick, NWP leadership was hesitant to give her time off. The election was so near, they said, Milholland could surely push on through the home

The Chicago Convention votes to create the National Woman's Party. *National Woman's Party at the Belmont-Paul Women's Equality National Monument, Washington, D.C.*

Left: A Chicago worker collects the wreckage of the NWP banners. *National Woman's Party at the Belmont-Paul Women's Equality National Monument, Washington, D.C.*

Below: NWP members protest President Wilson in Chicago. *Library of Congress.*

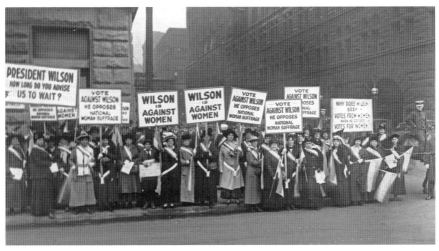

stretch. Milholland soldiered on but was much sicker than anyone knew. At a Los Angeles event on October 23, Milholland collapsed and was hospitalized. While she faded, President Wilson was reelected. The NWP campaign had only managed to defeat him in Illinois and Oregon; the other suffrage states handed him solid victories. A November 12 *New York Times* article crowed that the NWP had "failed utterly." On November 25, Milholland died. Her sister reported that her last words had been "President Wilson, how long must women wait for liberty?" It may not have been quite true, but it was certainly dramatic.

Alice Paul had reached the end of her patience. The NWP was in debt. Wilson was back in the White House. Not a single new state had passed suffrage. A federal amendment was as distant as ever. Nonviolent NWP members were beaten for their views. And now Inez Milholland had literally campaigned herself to death for the cause. The time for polite, ladylike behavior was over.

PICKETS, PROTESTS AND PRISONS

1917

On Christmas Day 1916, the Congressional Union closed out a frustrating year with a memorial service for Inez Milholland. Somehow, it secured permission to hold the ceremony in statuary hall of the U.S. Capitol, the first there honoring a woman. Dozens of memorial resolutions were read in Milholland's name, and the suffragists resolved to present them to President Wilson to remind him what was at stake in their ongoing struggle. On January 9, 1917, they had their chance. Three hundred women visited the White House and bluntly asked the president to support a federal amendment. The president was apparently surprised. He had expected the formal ritual of presenting memorial resolutions, not an overt lobbying effort. According to the *Washington Post*, the former professor resorted to a patronizing lesson in the realities of party politics. "In this country, as in every other self-governing country, it is really through the instrumentality of parties that things can be accomplished. They are not accomplished by the individual voice but by concerted action, and that action must come only so fast as you can concert it. I have done my best." If he expected nods and thanks, he got none. The women stared at him with blank silence. Wilson abruptly left the room.

With their intelligence and political savvy deeply insulted, the delegation walked back to Cameron House and immediately started plotting. The support of the president was key. And if he wouldn't give it willingly, they had to force his attention. Alice Paul and the executive committee had been quietly planning a new course of action, one they knew would cost them

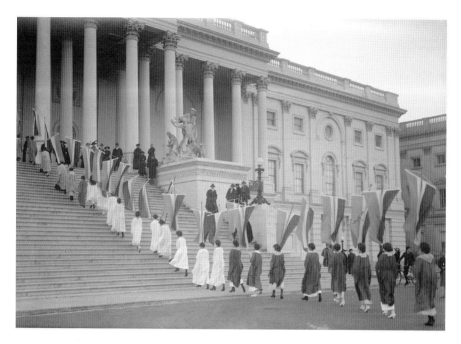

Mourners march up the Capitol steps to the Inez Milholland memorial service. *Library of Congress.*

supporters and public sympathy. But now seemed the perfect moment to present it to their outraged membership. Harriot Stanton Blatch took the floor. "We can't organize bigger and more influential deputations. We can't organize bigger processions. We can't, women, do anything more in that line. We have got to take a new departure. We have got to keep the question before him all the time. We have got to begin and begin immediately." The plan, Blatch revealed, was to picket the president. To stand by the White House gates with banners demanding a federal amendment. To stand, as Blatch put it, "as sentinels—sentinels of liberty, sentinels of self-government, silent sentinels." No one had ever done that before, not for one day. Yet here was the CU leadership proposing the suffragists do it every day until Wilson's second inauguration on March 4. According to Doris Stevens, they didn't hesitate. "No one suggested waiting until the next presidential campaign. We could wait no longer. Volunteers signed up for sentinel duty and the fight was on."

The first picketers set out the very next day, January 10, 1917. Paul released the news to the *Washington Post*, which dutifully printed it on the front page. "Women suffragists, after another futile appeal to President

Wilson yesterday for his support of the Susan B. Anthony Amendment, announced plans for retaliation by picketing the White House grounds with 'silent sentinels.' Their purpose is to make it impossible for the president to enter or leave the White House without encountering a sentinel bearing some device pleading the suffrage cause." Twelve women formed the first picket lines, six at each main White House gate. In addition to unlettered banners in the suffragists' purple, white and gold, a bigger banner read, "Mr. President, what will you do for woman suffrage?" Another carried Inez Milholland's supposed last words: "How long must women wait for liberty?" A little before 11:00 a.m., the president and his family returned from a round of golf. Pulling in to the White House gates, President and Mrs. Wilson looked directly ahead, expressionless. The president's daughter Margaret, a suffrage supporter, waved. The weather held, and the day was pleasant. The White House police were polite. Taking shifts, the pickets stayed there all day. No one seemed to find them outrageous or even remarkable.

The following day, January 11, the temperature hovered around freezing. The women shortened their shifts and passed around one huge fur coat. Again, they stayed all day. This time, when the president returned from golf, he smiled at the picketers and then sent a messenger inviting them to come have tea and warm up inside. The women declined. As the *Syracuse Herald* put it, "Some of the guiding spirits in the organization felt that it was not the part of the besieging force to be resuscitated by the besieged." Local

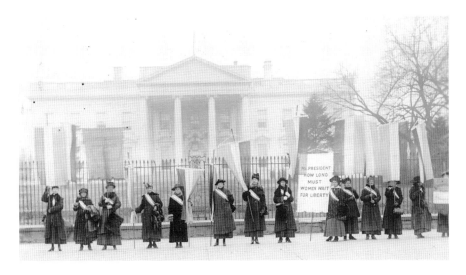

The pickets at the White House begin. *Library of Congress.*

Washingtonians and curious tourists stopped to stare or tip their hats in support. The women delighted in imagining the confusion and irritation of the crusty old members of the neighboring Cosmos Club, watching through their windows across Lafayette Square. Nothing dramatic happened. The silent sentinels kept appearing, their bright banners spots of color against the leafless winter landscape.

Within a week, news of the pickets spread around the nation, and the backlash began. CU members resigned and canceled their subscriptions to *The Suffragist*. Editorial writers slammed the picketers as cowardly and futile. Under the headline "Silent, Silly, and Offensive," the anti-suffrage *New York Times* declared only women would conceive of a tactic "compounded of pettiness and monstrosity," and that was exactly why they shouldn't vote. "The granting of suffrage would intrude into governmental affairs…a great many to whom that compound of pettiness and monstrosity seems natural and proper." Other suffrage organizations also objected. One unnamed suffragist editorialized in *New American Woman*, "Women of no class nor of any party can ever be excused for thus disporting themselves." Carrie Chapman Catt of NAWSA called the pickets "a childish method of appeal." Even Alice Paul's mother wrote to ask her to stop "annoying the president."

President Wilson drives by the White House pickets. *National Woman's Party at the Belmont-Paul Women's Equality National Monument, Washington, D.C.*

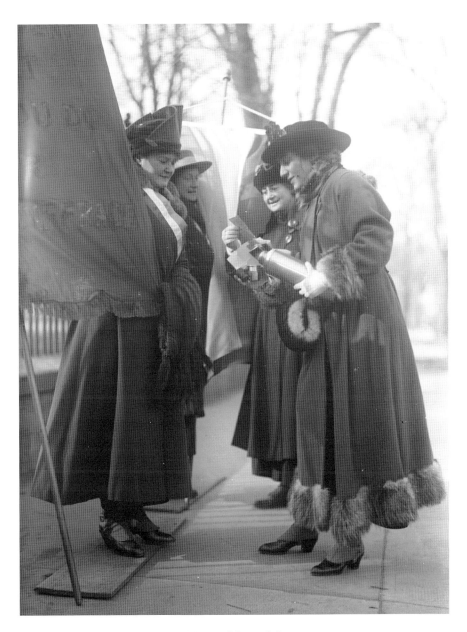

Supporters bring hot coffee to the picketers. *Library of Congress.*

But the pickets kept coming. To recruit volunteers and keep the story fresh for newspapers, Paul created themed days. The suffrage volunteers for Pennsylvania Day, New Jersey Day, Virginia Day, et cetera were dutifully covered in their local newspapers. College Day got a lot of press, as did the days set aside for women doctors, teachers and musicians. On February 12, Lincoln's birthday, the sentinels held a special banner that read, "Lincoln stood for woman suffrage sixty years ago—Mr. President, you block the national suffrage amendment today. Why are you behind Lincoln?" Three days later, on Susan B. Anthony's birthday, the picketers held a banner quoting their founding mother: "We press our demand for the ballot at this time in no narrow, captious, or self-seeking spirit, but from purest patriotism for the highest good of every citizen, for the safety of the republic, and as a glorious example to the nations of the Earth." In the press, CU members continued to remind readers, both pro- and anti-suffrage, how thoroughly nonthreatening and peaceful their efforts were. As Rheta Childe Dorr wrote in the *Chicago News*, "You may even believe that the women in Washington are hurting the cause. But does anyone suppose that a large masculine class barred from citizenship, absolutely discountenanced by the president, would do anything half as mild as stand at the gates of the White House carrying a banner?"

Alice Paul originally planned to wrap the picketing up with a big event on Inauguration Day, March 4. In the days preceding, the CU held a national convention and officially merged with the National Woman's Party, under the NWP name. Alice Paul was elected chairman. The convention passed several resolutions and decided officially to present those resolutions to the president in one enormous picket line, one thousand women strong. The women hoped that their show of force would push the president to meet with them and accept their resolutions and they could end the pickets. As Doris Stevens put it, "In our optimism we hoped that this glorified picket-pageant might form a climax to our three months of picketing. The President admired persistence."

March 4, 1917, turned out to be one of those horrible late winter days where the relentless wind blows the icy rain sideways. Undeterred, one thousand women set off from NWP headquarters with their banners. Stevens described the scene: "They marched in rain soaked garments, hands bare, gloves torn by the sticky varnish from the banner poles, and streams of water running down the poles into the palms of their hands." A crowd of spectators had gathered by the White House, kept in check by a huge police presence. Through the stinging rain, the women approached the main gate,

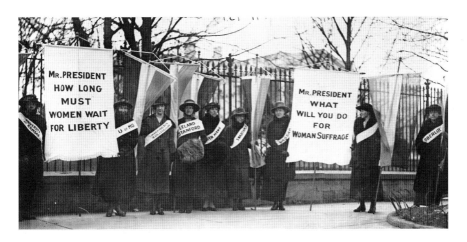

"College Day" on the picket line. *Library of Congress.*

only to find it locked against them. The guard said he had orders to keep them out. The procession moved around the building to a second gate at Pennsylvania Avenue, which was also locked. At the third locked gate, the small one near the executive offices, the marchers convinced the guard to take a message to the president's secretary. He was reprimanded and sent back to his post before he could deliver it. So the marchers kept circling the building in a defiant, soggy train, struggling to keep their banners from turning into spinnakers in the wind. The sight was impossible to ignore, if not quite the spectacle Paul had planned. Scripps correspondent (and NWP supporter) Gilson Garner described it as the most impressive thing he had seen in eighteen years of reporting on Washington: "Had there been fifteen hundred women carrying banners on a fair day the sight would have been a pretty one. But to see a thousand women—young women, middle-aged women, and old women—and there were women in the line who had passed their three score years and ten—marching in a rain that almost froze as it fell…was a sight to impress even the jaded senses of one who has seen much." The publicity was invaluable. A year later, Eleanor Booth Simmons wrote in the *New York Sun*, "The Sunday of Woodrow Wilson's inauguration, the day that a thousand pickets marched round and round the White House in the pouring rain, calling on the walls of Jericho to fall—well, 1000 dailies opened their pages to that stunt to the amount of on average half a column in a paper." But in the moment, the marchers weren't quite sure how this event would end. They circled the White House four times, the wind and rain never letting up for a second. Finally, in the late afternoon, the

Pennsylvania Avenue gate opened. But it was not to let the marchers in—it was to let the presidential limousine out. President and Mrs. Wilson looked straight ahead, studiously ignoring the soaked, freezing army that had them surrounded. Without a backward glance, they drove away. The suffragists had been dismissed. Once again, instead of being discouraged, the women were inflamed. "This one single incident probably did more than any other to make women sacrifice themselves," wrote Stevens. "Even something as thin as diplomacy on the part of President Wilson might have saved him many restless hours to follow, but he did not take the trouble to exercise even that. The three months of picketing had not been enough." There were no pickets on Monday, March 5. Yet again, the NWP needed to recover, regroup and plan a new strategy.

By March 1917, American involvement in World War I was inevitable. At the end of January, Germany resumed submarine warfare in part of the Atlantic, a direct threat to U.S. shipping interests. On February 4, President Wilson announced the United States was formally severing relations with Germany, the first step toward the ultimate declaration of war. While the Allies waited for that declaration, Wilson waited for an overt provocation. Then on February 28, newspapers began reporting an extraordinary offer from Germany to Mexico. If Mexico would join the Central Powers in the war and help recruit Japan, Germany would help recover Texas, New Mexico and Arizona from the United States. Wilson began preparing a message to Congress asking for a declaration of war. It was in that tense time, when war was inevitable but not yet a reality, that the NWP debated a new strategy. Then on March 8, Czar Nicholas was overthrown in Russia, and the new provisional government promised universal suffrage. On March 28, British prime minister Lloyd George announced his desire to give women the vote. The British war casualties had been so devastating, however, that at first only women over thirty were enfranchised, so they wouldn't outnumber the men. It felt like an international tide was turning.

The question of how to conduct a suffrage campaign in wartime was a thorny one. In England, Emmeline Pankhurst and the WSPU had suspended all suffrage work three years earlier. Their nation was in such peril, they reasoned, that there was no point in achieving the vote if they had no country in which to cast it. At NAWSA, members devoted themselves to the war effort, and both Catt and Shaw were appointed to the Women's Committee of the Council on National Defense. The general consensus was that wartime was not a time for self-interest. Any good patriot should drop his or her personal cause for the greater good of the nation and the Allies.

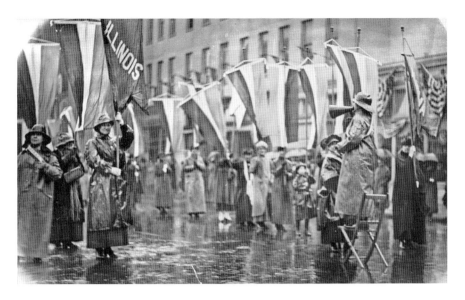

Preparing to march in the rain. *Library of Congress.*

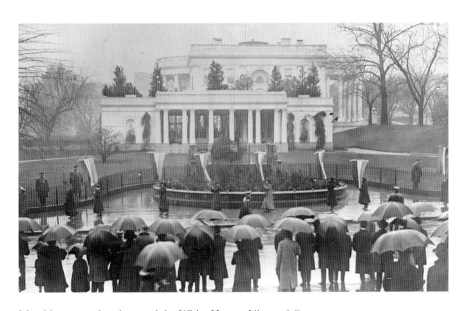

Marching around and around the White House. *Library of Congress.*

The president certainly shouldn't be distracted from his awful burden by pesky picketers. It would be hard to get attention from members of Congress or the press. The movement would be vilified for trying. Paul could not ignore the fact that a decision to keep fighting would lose more support than she gained.

And yet, there was terrible, naked hypocrisy in asking a nation to go to war for democracy, while denying it at home. American women were asked to economize, take factory jobs, plant gardens, send off their sons and husbands and brothers, all for a war declared by a government they had no part in electing. President Wilson was about to be thrust onto the world stage as the spokesman for democracy and justice. Wasn't this the perfect time to remind him that he could advance those causes at home? The United States wasn't in the same existential peril as the United Kingdom, and the NWP's tactics weren't as destructive as the WSPU's, so abandoning them was not as imperative. Plus, a lot of American women were against this war, and NAWSA was making them feel unwelcome. Couldn't the NWP provide a place for suffragists to keep up their work, regardless of their position on the war?

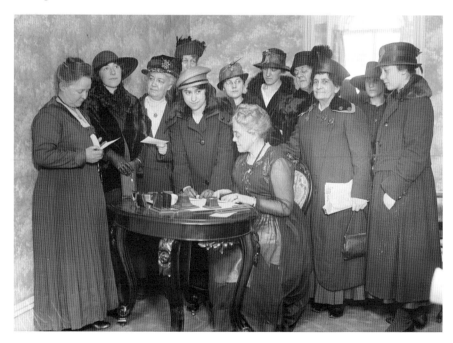

NAWSA members volunteer for the war effort at New York headquarters. *Library of Congress.*

And then there was the example of the Civil War. The founding mothers of the suffrage movement had put aside their priorities in favor of abolition, sure that their sacrifice and patriotism would be rewarded after the war. Then they were explicitly left out of the Fourteenth and Fifteenth Amendments and told they once again had to wait their turn. All momentum from 1848 onward was lost, and the movement had to begin all over again after Reconstruction. Paul had written her dissertation on suffrage history and had always considered the decision to abandon the effort during the Civil War to be a grave mistake.

On April 2, 1917, Wilson called a special War Session of the Sixty-Fifth Congress. He would address them, and the nation, that evening. Everyone knew he would ask for a declaration of war. That morning, not only were the NWP pickets back at the White House, but there was also a new picket line at the Capitol. Their banner read, "Russia and England are enfranchising their women in wartime. How long must American women wait for their liberty?" The reaction was swift and brutal. Even some stalwarts like Harriot Stanton Blatch, who had first presented the silent sentinel strategy, objected to continuing it in wartime. Some suffragists found it unpatriotic. "At a time like this, when there is so much women can do to help," wrote Myrtle Price, "it seems incredible that there are any in the whole world who would try to hinder our government and its representatives in their efforts to bring peace to this war-mad world." Others thought the pickets were simply a poor tactic. "I shall have to confess quite frankly," wrote Alice Carpenter, "that I think Mrs. Catt is playing a more intelligent game at the present moment than is the National Woman's Party." Meanwhile, the Democrats in Congress declared that only "war measures" would be included on the legislative agenda. So the NWP set out to convince the Wilson administration that suffrage was a war measure by pointing out the challenges of advocating democracy abroad while denying it at home. This contradiction formed the vulnerable underbelly of Wilson's presidency, and according to Doris Stevens, the suffragists "intended to expose this weakest point to the critical eyes of the world." To highlight the hypocrisy as sharply as possible, the picketers began to use Wilson's own words on their signs. When British foreign secretary Arthur Balfour met with Wilson a few weeks later, the banner quoted a line directly from Wilson's April 2 address to Congress: "We shall fight for the things which we have always held nearest our hearts—for democracy, for the right of those who submit to authority to have a voice in their own governments." On April 6, the United States officially declared war on Germany, and

the pickets continued throughout the spring. They became something of a fixture in Washington, drawing curious tourists and even the occasional honeymooner who would join the pickets for a day or two on a lark.

But the silent sentinels were not the NWP's only effort toward the federal amendment. They steadily amassed a massive database of information, kept on meticulously maintained index cards, about every member of Congress. This card index included not only where a given member stood on suffrage but also notes on any public (and some private) statements he had made on the subject. A card might note that a given senator always arrived at work early, and 7:30 a.m. was the best time to find him at his desk. Another might mention that a member of Congress loved golf, in which case the NWP could dispatch a pro-suffrage golfer to corner him on the links. The card file eventually filled a small room at Cameron House, and the information it contained was invaluable. Rumors even started that the women had hired detectives to ferret out dirt on elected officials. But the truth was much less scandalous and much more exhausting: the details came from countless deputations, meetings, parties, speeches and lobbying trips the women had conducted throughout the long years of the push for a federal amendment. For the Sixty-Fifth Congress, their lobbying efforts focused on treating suffrage as a war measure, getting it voted out of committee in the Senate and getting a suffrage committee created in the House. They kept that pressure up on the legislative front while the pickets kept the issue in front of the executive.

In June, the banners took a rhetorically aggressive leap forward. U.S. envoy Elihu Root, a vocal anti-suffragist, delivered a speech in Petrograd calling for Russia to continue to cooperate with the Allies and stay in the war. He praised the United States as the home of "universal, equal, direct and secret suffrage." Outraged NWP members immediately started working on a massive new banner. They even consulted a lawyer to make sure it wasn't libelous or possibly treasonous. When Russian diplomats visited the White House on June 20, Dora Lewis and Lucy Burns were standing by the gate with what inevitably became known as the "Russian Banner":

> *To the Russian Envoys: President Wilson and Envoy Root are deceiving Russia. They say, "We are a democracy. Help us win the war, so that democracies may survive." We, the women of America, tell you that America is not democracy. Twenty million American women are denied the right to vote. President Wilson is the chief opponent of their national enfranchisement. Help us make this nation really free. Tell our government that it must liberate the people before it can claim free Russia as an ally.*

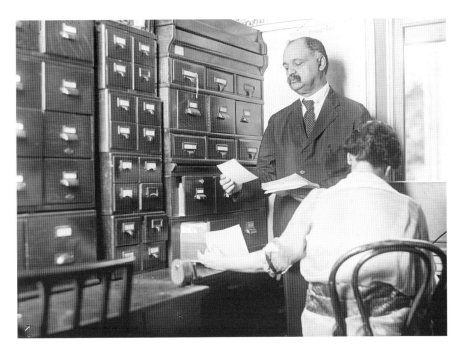

Inspecting the NWP's index card file. *Library of Congress.*

The Publications Room at NWP headquarters. *Library of Congress.*

The banner was so wordy that the Russian delegates couldn't possibly read it all as they drove by, even if their English was excellent. But of course, they weren't the intended audience. This message was for the press, the American public and the Wilson administration. In a press release issued the same day, Alice Paul drove the message home: "The responsibility for our protest is, therefore, with the Administration and not with the women of America, if the lack of democracy at home weakens the Administration in its fight for democracy three thousand miles away." The women knew the reaction would be swift and harsh. Doris Stevens was unapologetic. "Of course, it was embarrassing. We meant it to be. We believed the truth must be told at all costs." And the costs were high. The crowd in front of the White House slashed the banner with a knife and ripped it from the poles as Lewis and Burns stood silently by. The press congratulated the crowd and declared the banner "unveiled treason." The *New York Sun* suggested the NWP had "been transformed into a bureau of German propaganda." Carrie Chapman Catt called them "unwise, unpatriotic, and unprofitable to the cause of suffrage." In openly accusing the American president of deceit, the NWP had finally gone too far.

The next day, more pickets appeared with a duplicate banner. The crowd again tore it down. The mood was turning dangerous. That evening, June 21, Police Chief Raymond Pullman showed up at Cameron House. Pullman had replaced Richard Sylvester two years earlier and was generally considered a friend to suffragists. He asked Paul to stop the pickets. If she didn't, he warned, the women would risk arrest. Paul refused, declaring that picketing had been considered perfectly legal for six months and the law hadn't changed overnight. The right was protected by the 1914 Clayton Act, an amendment to the Sherman Antitrust Act, which ensured the right of unions and other groups to strike, boycott and picket. Confident in their righteousness, Lucy Burns and Katharine Morey marched out the next day—not with the Russian banner this time but with the one quoting Wilson's words from April 2. At first, nothing happened. Rumors of arrests had drawn a crowd, but when no police showed up, the disappointed onlookers dispersed. Eventually, some officers arrived to arrest Burns and Morey and take them to the station house, where they demanded to know the charges against them. This, apparently, was a stumper. They couldn't be arrested for picketing, as that wasn't illegal. They hadn't incited a riot or engaged in disorderly conduct; they had stood peacefully and silently. Hours passed. Finally, Burns and Morey were told they were charged with "obstructing the traffic" on Pennsylvania Avenue. They were released on

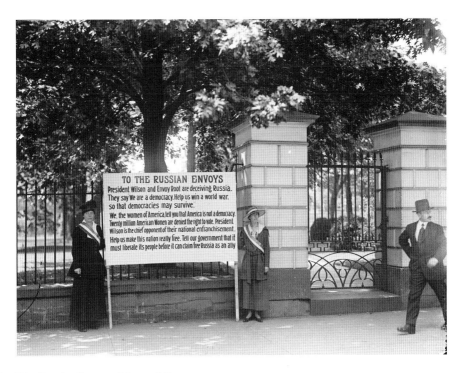

The Russian Banner. *Library of Congress.*

their own recognizance and never brought to trial. The next day, four more women were arrested, charged with "obstructing the traffic" and then dismissed. Clearly, the police force and the administration hoped the arrests alone would frighten the women off. Anyone paying even a little bit of attention could have told them they hoped in vain.

On June 26, six more women were arrested. This time, they were brought to trial. All six were convicted of obstructing the traffic. It was not a jury trial. Police Court judge Alexander Mullowney gave the women a choice of a twenty-five-dollar fine or three days in jail. All chose jail. They were sent to the District Jail, a dark, nineteenth-century brick building on the east side of Capitol Hill. It was hardly a day at the beach but survivable for seventy-two hours. The NWP sent the women off with towels, snacks and nightgowns. Mabel Vernon found an organ and led the inmates in a singalong. The *New York Times* gloated they weren't there long enough to become martyrs, in an article headlined "Militants Get 3 Days; Lack Time to Starve." Their sentences over, the women took taxis back to Cameron House, where they were welcomed with a huge breakfast and a strategy session to plan the next

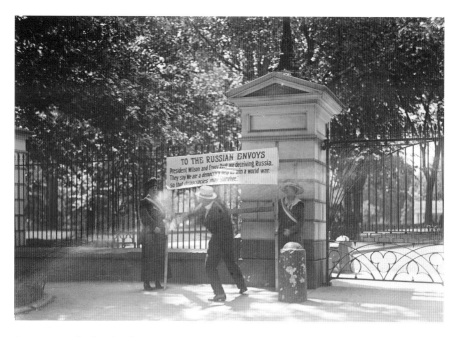

A man tears the Russian Banner. *Library of Congress.*

move. The picketers were arrested routinely now, and since they continued despite demands to stop, the police did not protect them from angry crowds. And the crowds were getting angrier. As the first American soldiers landed in Europe, public patience for protest and criticism fell sharply off. Other political action groups were also feeling the sting of intolerance and accusations of treason. But still, the women persisted. They decided to concentrate their efforts on two dates with huge symbolic resonance that were most likely to get them press coverage: Independence Day (July 4) and Bastille Day (July 14).

While the women were planning those events, Alice Paul fell gravely ill. At first, she was diagnosed with Bright's disease, the same kidney inflammation that had killed President Wilson's first wife, Ellen. She was sent to a clinic to rest, while the movement continued without her. Dora Lewis took over fundraising. Lucy Burns, who had already been arrested several times, became NWP chairman. After a few weeks, Paul was moved to Johns Hopkins, where it was discovered she didn't have Bright's disease, just fatigue, a terrible diet and a back-breaking work schedule. She repaired to her family's farm in New Jersey for some much-needed recovery time.

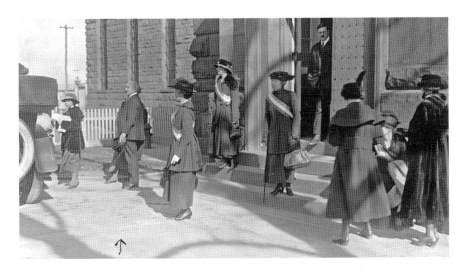

An NWP member leaving the District Jail. *Library of Congress.*

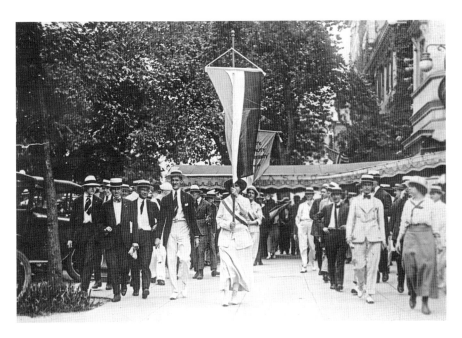

Preparing to picket on Bastille Day, July 14, 1917. *Library of Congress.*

She missed a dramatic month. On July 4, eleven women marched from Cameron House to the White House carrying banners. When they took up their posts at the White House gates, the holiday crowd saw that one banner paraphrased the Declaration of Independence: "Governments derive their just powers from the consent of the governed." As the crowd jeered, policemen grabbed the banners and arrested the women. The irony of being arrested for demanding liberty on Independence Day earned the suffrage movement its first front-page story since the declaration of war. Judge Mullowney once again sentenced the women to three days in the District Jail.

A bigger show was planned for Bastille Day. This time, sixteen women were involved. Several of them were socially prominent, including the daughters and wives of politicians, ambassadors and journalists. One banner read "Liberty, Equality, Fraternity, July 14 1789." Another paraphrased Inez Milholland: "Mr. President, how long must American women wait for liberty?" Once again, the women were arrested for obstructing the traffic and hauled before Judge Mullowney. This process was becoming routine. As in earlier trials, the women argued that they had violated no laws and that

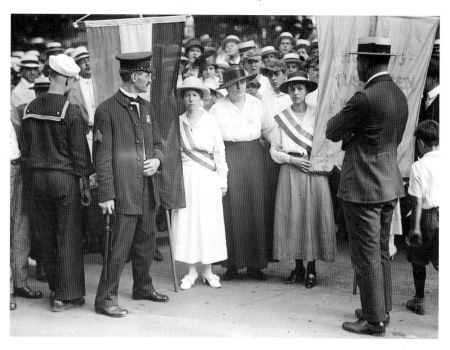

Police confront picketers. *Library of Congress.*

their arrests were purely political. But this time, the judge veered off the script. He gave the women a choice: pay a twenty-five-dollar fine or spend sixty days in the workhouse. Perhaps he thought the disproportionately harsh sentence would finally get the NWP to back down. But once again, he had underestimated their determination. Every single one of the sixteen refused to pay the fine, equating it to an admission of guilt. They were packed off to the District Jail and then transported in prison wagons to Pennsylvania Station, where they boarded a train for Occoquan, Virginia, a mill town in Prince William County. In 1910, D.C. had opened a workhouse in Occoquan, where the inmates made bricks, farmed and tended orchards. The Women's Workhouse was added in 1912, largely for women convicted of prostitution, vagrancy and public drunkenness. The female inmates did the laundry and sewed clothes for the prisoners. The imposing dormitories, many still standing today, were built from the bricks the prisoners themselves had made. It was intended to be a Progressive-era example of prison reform, open and light with plenty of fresh air and nature. Still, it was not the kind of place these sixteen women had ever dreamed of going. "Even the bravest member of our party," wrote Doris Stevens, "was struck with a little terror." The women were forced to give up everything they had brought with them, including toiletries and eyeglasses. Forbidden to speak, they were commanded to strip naked, herded into a shower and then given the hated uniform of itchy, ill-fitting dresses. Stevens described them in wry detail: "The thick unbleached muslin undergarments were of designs never to be forgotten. As were the thick stockings and forlorn shoes." The women were sent to a large open dormitory with other inmates and introduced to Warden Raymond Whittaker, the iron-fisted tyrant of Occoquan. He told them they would be allowed to write one letter a month, all incoming and outgoing mail would be monitored and censored and they would receive work assignments in the morning.

At Cameron House, Lucy Burns and the rest of the NWP were milking this shockingly harsh sentence for all it was worth. As Burns wrote to Alva Belmont, "It was a good stroke of fortune that this was the group selected by the magistrate for the indefensible sentence of sixty days in the workhouse!" They sent telegrams to the hometown newspapers of each of the sixteen women. One quote was picked up in several of the accounts: "It is unpatriotic, we are told, to complain of injustice now. We believe that it is unpatriotic not to complain. We have no right to allow our representatives to act basely—to preach freedom abroad, and deny freedom at home." The prominent male relatives of the prisoners also publicized their unjust

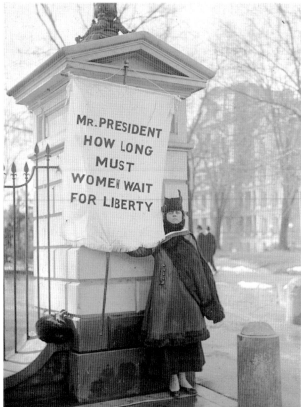

Above: The workhouse at Occoquan, Virginia. *Library of Congress.*

Left: Alison Hopkins holds a banner asking Inez Milholland's final question. *Library of Congress.*

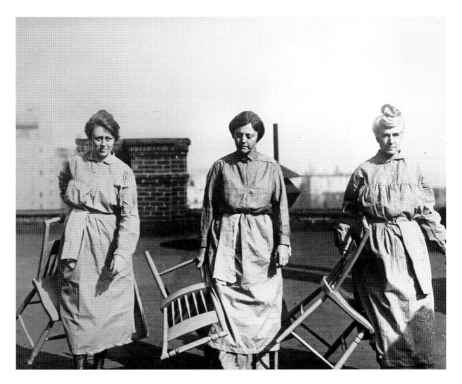

Doris Stevens, Alison Hopkins and Eunice Brannan in Occoquan uniforms. *Library of Congress.*

treatment. J.A.H. Hopkins and his wife, Alison, had recently dined with Woodrow and Edith Wilson. Now Alison was in Occoquan and J.A.H. was livid. He stormed to the White House and demanded of the president, "How would you like to have your wife sleep in a dirty workhouse next to prostitutes?" Public opinion began to shift. "For the first time, I believe," wrote Stevens, "our form of agitation began to seem a little more respectable than the Administration's handling of it." After three days, Wilson bowed to the pressure. Warden Whittaker summoned the prisoners and told them the president had pardoned them. But he sent them off with an ominous warning: "The next lot of women who come down here won't be treated with the same consideration that these women were."

Although happy to leave the workhouse, the women did not like to feel beholden to the president. Alison Hopkins wrote Wilson a letter, which she also released publicly, reminding the president that she did not want favors, only fairness. She underscored her point by picketing with a banner that read, "We do not ask pardon for ourselves, but justice for all American

women." The NWP saw the unasked-for pardon as vindication of its tactics. Writing in *The Suffragist*, Paul called the pardon "the government's complete and sudden surrender" and hoped it would close "a chapter in the American woman suffrage struggle as ignoble as was the witchcraft chapter in the history of this country." Picketing continued without arrests or other incidents through the rest of July and the beginning of August. It was getting harder to find willing participants in this daily task, but Paul, for one, didn't mind the attrition. She wrote, "We sort of emerged from all this with, maybe, the sturdier feminists, people who wanted to continue anyway." The federal suffrage amendment remained stalled; the Senate Suffrage Committee had still not recommended the bill to the full Senate, and the House had yet to create a suffrage committee. Democratic leaders told NWP lobbyists that only war measures would be considered for passage, and suffrage didn't qualify. The suffrage pickets and arrests no longer made headlines, and this static state of affairs threatened to drag on indefinitely.

It was time for a stunt that revived national attention. On August 14, 1917, the picketers carried a new banner, which read, "Kaiser Wilson: Have you forgotten how you sympathized with the poor Germans because they were not self-governed? Twenty million American women are not self-governed. Take the beam out of your own eye." This was another rhetorical escalation, comparing Wilson to the hated enemy Kaiser Wilhelm. The crowd on the White House sidewalk revolted, ripping the banner from the women and pushing them to the ground. Another Kaiser banner replaced it. This, too, was snatched and destroyed. Lucy Burns hung banners from the balcony of Cameron House, but someone grabbed a ladder from the Belasco Theater next door and ripped them down. Women continued to march out of headquarters with banners and continued to be attacked by the crowd. At some point, a shot was fired into Cameron House. The police did nothing. The next day, the increasingly angry crowd grabbed fifty banners, and Alice Paul was dragged along the sidewalk by someone trying to tear her sash. On the third day, the mob destroyed dozens of banners and, encouraged by police inaction, attacked the women more roughly. On August 17, the police decided to act and began arresting not the unruly members of the crowd but the picketers. Throughout the rest of the summer and fall, some 500 women were arrested, with 168 serving time in jail. Thirty or sixty days at Occoquan, once so outrageous, became standard sentences. No more pardons were forthcoming, and Warden Whittaker followed through on his promise of ill treatment. The women were fed rancid meat and soup with worms floating in it. They were not allowed contact with the outside world. Sanitary

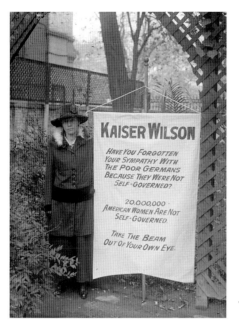

The Kaiser Banner. *Library of Congress.*

conditions were disgusting, and disease was a constant threat. Still, the women continued to picket. Perhaps hoping to look like they weren't totally heartless, leaders in Congress did make incremental progress. In September, the federal amendment was finally reported out of the suffrage committee and sent to the full Senate. The House decided finally to form a suffrage committee. The pickets didn't stop. Since the carrot hadn't worked, the administration returned to using the stick and pressured Judge Mullowney to increase the women's jail sentences.

In October, the special war session of the Sixty-Fifth Congress adjourned without voting on the federal amendment. Paul led the pickets the very next day, carrying a banner that once again quoted President Wilson: "The time has come to conquer or submit; for us there can be but one choice—we have made it." She was duly arrested. As a repeat offender, she was sentenced to a whopping seven months in the District Jail. Lucy Burns was serving one of her many stints at Occoquan. At both prisons, they decided to employ the tactic they had learned from their British counterparts years earlier and demand political prisoner status. Their demands gained them public sympathy, as did news of the deplorable conditions in both prisons. Wilson knew he had to act. He let it be known that political prisoner status would never be considered under any circumstances. Doing so would set a terrible precedent in wartime, when the jails were filling up with conscientious objectors and those suspected of espionage and treason, people who might also demand political prisoner status. Journalist David Lawrence reportedly told Paul in jail, "It would be easier to give you the Federal Amendment than to treat you as political prisoners." She and Rose Winslow, also held in the District Jail, began a hunger strike in protest. The prison authorities called in a doctor from St. Elizabeth's Insane Asylum and tried to have Paul committed. The doctor found Paul sane but did order force-feeding. Having experienced that

horrible ordeal in England, Paul knew what to expect. But it was a new terror for Winslow, who managed to leak details of the experience out to the press: "Don't let them tell you we take this well. Miss Paul vomits much. I do too.…We think of the coming feeding all day. It is horrible."

On November 10, Lucy Burns, freshly released from Occoquan, planned one last magnificent picket. Forty-one women, the longest line yet, marched to the White House to protest the treatment of Paul and the continued inaction on the federal amendment. They were arrested but, confusingly, released. They went back to the picket lines. They were arrested again but were told the judge wasn't ready to hear their case. They returned to the White House one more time. Thirty-one of them were arrested once more. Finally, on November 13, Judge Mullowney handed down his sentences. Seventy-three-year-old Mary Nolan was given six days. Most women were sentenced to fifteen or thirty days. Repeat offenders Dora Lewis and Eunice Brannan each got sixty days, and the incorrigible Lucy Burns was given six months. All were sent to the District Jail to join Paul and Winslow.

But for reasons never really explained, the women were diverted to the workhouse instead. Perhaps the prospect of some thirty more prisoners overwhelmed the warden of District Jail. Perhaps authorities wanted to keep Paul and Burns apart so they couldn't plan together. Whatever the reason, the women were put on the train to Occoquan, where they would endure what ever after was known as the "Night of Terror." The women had agreed that Dora Lewis would act as their spokesperson. When they arrived at the workhouse, Lewis told the matron they wished to be treated as political prisons and asked to see Warden Whittaker. When Whittaker arrived, he burst furiously through the door with a crowd of men. When Lewis turned to address him, he yelled, "You shut up. I have men here to handle you." Some of the men dragged Lewis away. Others grabbed the other women, including the elderly Mary Nolan, who said she was "jerked down the steps and away into the dark." Although most prisoners slept in open dormitories at Occoquan, there were some small stone "punishment cells" along one corridor of the men's prison. It was here the women were dragged and bodily thrown into the cells in the darkness. Nolan lost her balance and fell against the iron bed. Into the same cell, the men tossed Alice Cosu, who hit the back wall. They hurled Dora Lewis so hard she smacked her head on the bed and fell, limp, to the filthy floor. Nolan and Cosu thought she was dead and, terrified, screamed for help. Their cries joined the general noise of wails and shouts as women were dragged, shoved, wrenched and thrown. Lucy Burns began to call out the women's names one by one in the darkness to make sure

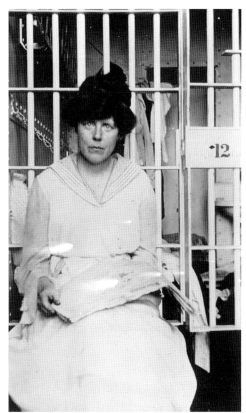

Right: Lucy Burns in a cell at Occoquan. *Library of Congress.*

Below: NWP members hold banners demanding political prisoner status for Alice Paul. *Library of Congress.*

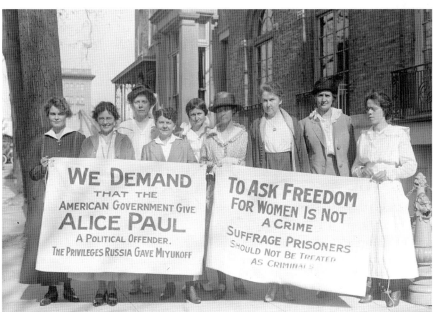

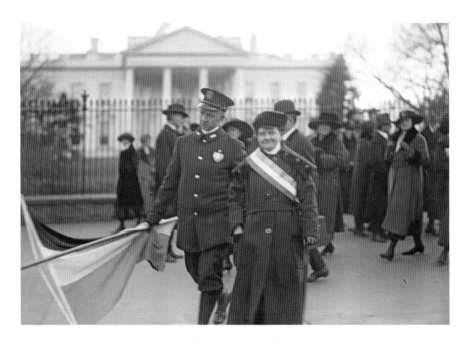

A picketer is escorted from the White House sidewalk. *Library of Congress.*

they were okay. Dora Lewis revived enough to assure the others. Whittaker reappeared and demanded silence. Burns continued to call out names, so Whittaker had her handcuffed with her arms chained above her head. Cosu began to vomit, and her cellmates worried she was having a heart attack. They called for help, to no avail. The cells were freezing and filthy, with open, waste-filled toilets. The only light came from the corridor. The women resolved to follow Paul's example and hunger strike, knowing the putrid workhouse food would be easy to refuse. Mary Nolan was released after her six-day sentence and brought word of their mistreatment back to NWP headquarters. As the hunger strike continued, Nolan reported, Whittaker tried to tempt the women with hot milk and warm toast and finally with fried chicken. The women left the food for the rats. Whittaker placed the blame for the women's stubbornness squarely with Burns and Lewis and decided to send them to the District Jail. But first he ordered a round of force-feeding so they wouldn't be quite so fragile and sympathetic. As Burns described it, "It hurts nose and throat very much and makes nose bleed freely. Tube drawn out covered with blood. Operation leaves one very sick."

Even while the NWP milked the publicity value of the cruel plight of women who had, after all, only been charged with obstructing traffic, their

lawyers developed a plan for getting the prisoners released. The longer the hunger strike continued, the more there loomed the very real possibility some of them wouldn't survive it. The lawyers focused on the fact that the women had been sentenced to the District Jail yet transported to Virginia. They filed a writ of *habeas corpus*, a legal maneuver requiring a prisoner to be physically brought to court to determine if her detention is legitimate. The lawyers knew the writ might only result in the women's transfer, not release. But it was all they had. The trial was set for November 23. Warden Whittaker, knowing his cruelty was about to be exposed, dodged the subpoena server six times before he was finally caught.

The trial focused entirely on why the women had not been imprisoned in D.C. District Jail warden Louis Zinkhan testified that he had sent the "able bodied prisoners," those "able to perform useful work," to Occoquan for "humanitarian motives." At this point, the NWP lawyer asked tiny, frail, septuagenarian Mary Nolan to rise as an example of such a woman. The point was made. Judge Mullowney suggested to Zinkhan that perhaps some of the women were too sick or weak to continue with their sentences.

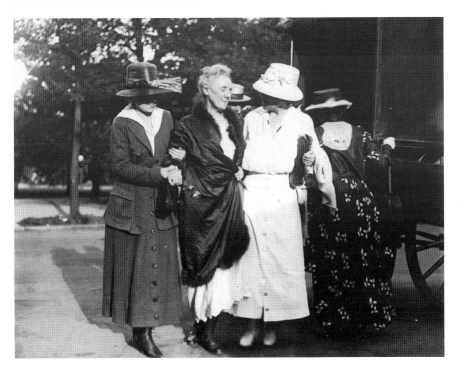

An ailing Dora Lewis is led from Occoquan after the hunger strike. *Library of Congress.*

Zinkhan agreed, writing that in his opinion "all of the suffragists" should be released. And on November 27 and 28, that's exactly what happened. The women were freed unconditionally. As Doris Stevens crowed, "With thirty determined women on hunger strike, of whom eight were in a state of almost total collapse, the Administration capitulated. It could not afford to feed thirty women forcibly and risk the social and political consequences; nor could it let thirty women starve themselves to death, and likewise take the consequences. For by this time one thing was clear, and that was that the discipline and endurance of the women could not be broken."

The prisoners returned to Cameron House, where they were celebrated as conquering heroes. They had held firm, outlasted every challenge and made the men regret underestimating them at every turn. They were jubilant. But they still didn't have the vote.

Chapter 4

DOWN TO THE WIRE

1918–1919

At the end of 1917, the NWP lost its headquarters. The whiskered old men of the Cosmos Club, whom the suffragists had delighted in gently taunting, bought Cameron House in order to expand their membership. (Although not, of course, to women. The Cosmos Club did not accept female members until 1988.) Fortunately, the party was able to move just across Lafayette Square to an elegant townhouse at 14 Jackson Place, still an easy walk to the White House. The new building wasn't furnished, so suffragists borrowed, bartered and donated enough furniture to suit the NWP's needs. It felt like a new year and a new beginning.

Perhaps President Wilson was also looking for a fresh start. On January 9, 1918, he met with Democratic Party leaders to discuss the coming election year. The women of New York had finally won the right to vote, and all those new voters made it more politically risky for Democrats to oppose the federal suffrage amendment. To the astonishment of the men in the room, Wilson announced his support, for the first time, of a constitutional amendment recognizing women's right to vote. All of his previous objections—states' rights, Democratic Party platform, not a wartime measure—fell before political realities. If women were going to vote, they might as well vote for Democrats.

The next day, newspapers around the country carried the news on their front pages. "Wilson Backs Amendment for Woman Suffrage" trumpeted the *New York Times*. "Give Vote to Women Is Advice by Wilson" ran the headline in the *Washington Post*. Carrie Chapman Catt and NAWSA issued

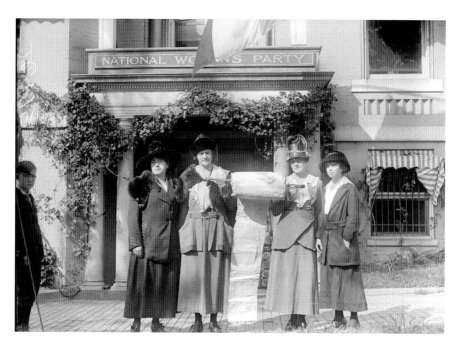

Suffragists pose with a petition in front of the new NWP headquarters at 14 Jackson Place NW. *Library of Congress.*

a statement saying they were "thrilled by the President's statement." Anna Howard Shaw said, "Onward with our President, the great leader of democracy." But the language the president used, while supportive, fell short of a full-throated battle cry. He noted that he would have preferred each state to decide the matter but that "in view of conditions existing in the United States and the world generally he felt free to advise submission of a federal amendment to the States." Those conditions, presumably, included the fact that Belgium, France and Canada were enfranchising women, and the United States was looking more like an outlier. Wilson also added the disclaimer that "any member of congress opposed to woman suffrage for any reason ought not to vote other than his convictions." Perhaps that's why Alice Paul's reaction was a little less gushing than her counterparts at NAWSA. Under the subhead "Chief of Pickets Gratified," Paul's statement on behalf of the NWP was a study in restraint: "It is difficult to express our gratification at the President's stand. For four years we have striven to secure his support for the national amendment for we knew that it and perhaps it alone, would insure our success." She added what could easily be read as a thinly veiled threat:

"Six sevenths of the Republicans have already pledged their votes. The Democrats undoubtedly will follow their great leader." She must have choked a little on the word "great."

The test of Wilson's influence was not long coming. The House of Representatives introduced the Susan B. Anthony Amendment that very day, January 10, 1918. To pass, the amendment needed a two-thirds majority, 274 votes. Suffragists from NAWSA and the NWP crowded the Capitol galleries. Jeannette Rankin, Republican of Montana and the first woman elected to Congress, opened the debate. Echoing the message of so many picket banners, Rankin asked, "How can we explain if the same Congress that voted for war to make the world safe for democracy refuses to give this small measure of democracy to the women of our country?" Because the president's statement had come so late, Paul and the NWP lobbyists had no way of knowing in advance how many votes had swung their way as a result. They did not know if they were watching a nail biter or a comfortable victory. Fortunately, the pro-suffrage members of Congress left nothing to chance. One arrived to the vote on a stretcher, newly missing his appendix. One slipped on the ice but refused to have his broken bone set, worried it would keep him from the Capitol. Another congressman lost his wife the night before. But she had been a suffragist, so he left his grieving family just long enough to vote for the amendment in her honor. When the final vote was tallied, it was clear these heroics had been absolutely necessary. The amendment passed without a single vote to spare, 274–136.

The victory celebrations were sincere but brief. Two-thirds of the Senate, sixty-four men, still had to approve the amendment for it to be sent to the states for ratification. And by Paul's count, they were still eleven senators short. If the Senate did not pass the bill in this Congress, the House vote would have to be reintroduced and rewon in the next. Paul now set a goal to ensure women could participate nationwide in the 1920 presidential election. With a little luck, women might even be able to vote in the primaries. Wilson wouldn't run again, and new presidential candidates each vying for the new female electorate could have a real impact on public policy. The deadline also added a sense of urgency to the tedious tasks of nose counting and arm-twisting. Time was now of the essence. Eleven senators must be convinced to change their position on suffrage before the Sixty-Fifth Congress recessed in October for the 1918 elections. There would be another short lame-duck session of this Congress from December 1918 to March 1919, but waiting until then would shrink the timeline for ratification. It was time to go back to the card file.

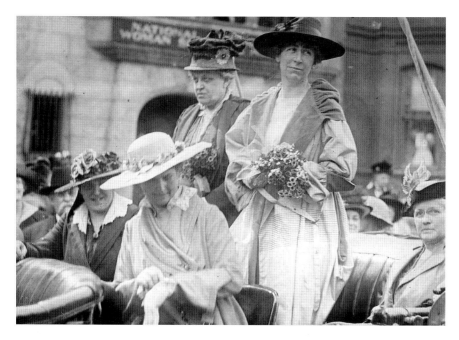

Jeannette Rankin with Carrie Chapman Catt. *Library of Congress.*

The file had to be continually updated and added to as new members were elected or changed their positions. It took up a lot of space and had earned the NWP some excellent press. Even the anti-suffrage *New York Times* was grudgingly impressed. "At the headquarters of the National Woman's Party in Washington is a card index system so extensive in detail, political and personal, that twenty-two different cards are required for each senator and representative," the paper explained in a breathless article. "To the index, and the machinery it sets to work, chief credit is given for the gains in votes in favor of the amendment." Fully ten senators died during the Sixty-Fifth Congress, and NWP lobbyists scrambled to discover the positions of their replacements. The legislatures in a couple of states endorsed suffrage, and their senators followed suit. At least one senator changed his mind on President Wilson's advice. Another was swayed by telegrams and editorials (many planted by the NWP) in his home state newspapers. Former president and suffrage supporter Theodore Roosevelt leaned on a few Republican colleagues. Lobbyists from the NWP and NAWSA continued to press the issue by any methods available. There was still no love lost between the two organizations, but the NAWSA had finally come around to putting effort

behind the federal amendment. Its representatives prided themselves on being the "front door lobby," since they could arrange official meetings with men who found their polite persuasion easier to take than their rivals' more confrontational strategy. The NWP lobby was decidedly back door. Maude Younger wrote a magazine article called "Revelations of a Female Lobbyist" in which she revealed the more ridiculous reactions from her targets. Senator Thomas Martin, a Democrat from Virginia, "would not sit down and talk suffrage, nor would he stand up and talk it. The only way to discuss suffrage with Senator Martin was to run beside him down the hall." She described the senator almost breaking into a jog as he tried to jump on the members-only elevator, where Younger could not follow. "It was interesting to talk suffrage with Senator Martin, and very good exercise."

By mid-June 1918, they were still three votes shy of victory. Or maybe two, or maybe four—a couple of coy senators kept both sides guessing. Twice the chairman of the Senate suffrage committee tried to bring the matter to a vote, hoping a few key opponents wouldn't show up. Twice he had to withdraw the motion, facing certain defeat. Meanwhile, Paul's fears that Wilson would be a less-than-enthusiastic suffragist were proving correct. He had said almost nothing on the issue since the House vote in January. Paul was certain a strong message from him to the Democrats in the Senate would be more than enough to convert the remaining three votes, but he seemed unwilling. On July 4, he gave a rousing speech at George Washington's tomb at Mount Vernon. "What we seek," he declared, "is the rule of law, based on the consent of the governed." There was no mention of suffrage, no acknowledgement that he governed an entire sex without their consent. The NWP reluctantly decided, once again, that it had to get the president's attention.

The members of the NWP were not eager to resume militant tactics. No one wanted to bring back pickets, jail and hunger strikes. Their point had been made, they thought; the amendment was before Congress, and the president had expressed his support, if somewhat weakly. The women hoped the home stretch of this race might be run in the corridors of the Capitol, not back out on the streets. In March, the U.S. Court of Appeals had thrown out their "obstructing the traffic" convictions, saying the women had never actually violated any laws. Yet they had been imprisoned, beaten, force fed, harassed and vilified. What had it all been for, if not to finally have a time when those tactics *weren't* necessary? Yet the amendment might die here, a couple votes short of passage, when more forceful support from the president could push it over the finish line. Their efforts had already influenced Wilson

Suffragists lobbying on Capitol Hill. *Library of Congress.*

this far. Perhaps they could plan a public demonstration that would make the news and get his attention without getting them arrested. Inez Milholland's birthday was August 6, which gave them a month to plan something solemn and eye-catching, and that would keep them out of jail.

The public square between the NWP headquarters and the White House was (and still is) named for Major General Marquis Gilbert de

Lafayette, hero of the Revolutionary War and defender of democracy both in the United States and in his native France. A massive statue of the Marquis stands in the square's southeast corner, depicting him in civilian dress, asking the French National Assembly to help secure democracy for America. Here was a fitting, convenient and legal place to hold a dignified public event. On August 6, 1918, dozens of women from all over the country, all dressed in white, marched from NWP headquarters to the statue. Most carried flags in the party's purple, white and gold. A few held banners made for the occasion. One, inevitably, asked Milholland's last question: "How long must women wait for liberty?" The other left no doubt as to the object of this demonstration: "We protest against the continued disenfranchisement of American women, for which the president of the United States is responsible. We demand that the president and his party secure the passage of the suffrage amendment through the Senate in the present session." The women circled Lafayette's statue. Dora Lewis stood in front of the bronze bare-breasted woman at the statue's base, which represents America passing Lafayette a sword. She began to speak to the growing crowd. She managed only one sentence before she was arrested. Hazel Hunkins took her place and resumed the speech. She, too, was arrested. One by one, women tried to speak, sing or simply stand with banners high, and all lasted only moments before being placed under arrest. All told, forty-eight women were taken to the police station. There, they were told that the order to arrest them came from Colonel C. Ridley, the president's military aide. All were released on bail and told to return the next day.

But when they returned, a confused district attorney confessed that he didn't know why they had been arrested. He needed some time, he said, to figure out which law, if any, these women had actually broken. The outraged women demanded to be dismissed if there were no charges against them. But the judge just told them to come back on August 15 to give the government lawyer time to figure it out. Meanwhile, the women kept assembling at the Lafayette statue and kept getting arrested.

By the time of the trial, the district attorney had settled on two charges: "holding a meeting in public grounds" and, obscurely, "climbing on a statue." Any woman convicted of both counts would receive a double sentence. As Doris Stevens describes it, "The familiar farce ensued." The women refused to acknowledge any wrongdoing. Since they had no power to consent to the government, they said, they should not be beholden to its judgment. Twenty-four women were convicted and sentenced to ten to fifteen days.

The statue of Lafayette in Lafayette Square. The bare-breasted woman at the base represents America. *Library of Congress.*

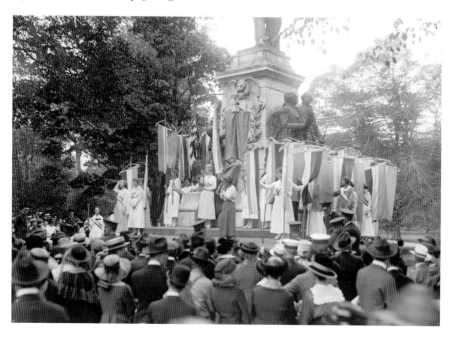

NWP suffragists surround Lafayette's statue. *Library of Congress.*

But here, the familiar script changed. Instead of being sent to the D.C. District Jail or Occoquan, they were told they would serve their sentences in an abandoned men's workhouse on the grounds of the district prison. "Hideous aspects which had not been encountered in the workhouse and jail were encountered here," claimed Stevens. The whole place was dark and freezing. It smelled nauseatingly of swamp gas and rot. The drinking water made them all sick. Since the cots in the foul cells were made from unforgiving iron, the women dragged their blankets into the stone corridor and huddled together for warmth. And they immediately began to hunger strike. When members of Congress came to visit their constituents in jail, they found them weak, sick and shivering. After five days, the Wilson administration bent to public pressure and released the women. They also issued a permit that allowed them to demonstrate in Lafayette Square. Political demonstrations have been staged there ever since. The NWP planned another one for September 16 and went back to the Senate.

The news there was not encouraging. The chairman of the Senate Rules Committee had no plans to schedule a vote on the amendment before the election recess. The chairman of the Senate Suffrage Committee wasn't planning to convene his group at all before the recess. The NWP still had no

The abandoned jail used for suffrage prisoners in 1918. *Library of Congress.*

access to Wilson himself, so it went ahead with plans for the September 16 event, the best method of communicating with the president. A few hours before the demonstration, Wilson invited Carrie Chapman Catt and the less aggressive suffragists of NAWSA to meet with him at the White House. "I have endeavored to assist you in every way in my power," he told the women, "and shall continue to do so. I will do all I can to urge the passage of the amendment by an early vote." When the NWP got wind of this statement, it immediately checked back in with the men in Senate leadership. No, they reiterated, they felt no pressure from the president to schedule a vote. It wasn't going to happen.

This confirmed all the NWP's fears that the president was paying lip service to its cause while refraining from any real action. The polite women of NAWSA might be appeased by empty words, but the NWP would not. The demonstration that evening took on a new tone. Again at the base of Lafayette's statue, the women lit a torch. Lucy Branham stood before the crowd with a piece of paper in her hand. "The President has given words and words and words," she declared. "Today women receive more words. We announce to the President and the whole world today, by this act of ours, our determination that words shall no longer be the only reply given to American women." And then she burned the paper and words to ashes.

The next day, the chairman of the Senate Rules Committee declared that debate on the Susan B. Anthony Amendment would begin in the Senate on September 26. Many of the speeches rehashed the same old arguments both for and against suffrage. But a new theme arose from some Democrats. The election of 1918 was just a few weeks away. With a growing number of statewide suffrage measures, more women would vote than ever before. And if the Republican Party was allowed to maintain its reputation as the sole champion of suffrage, the Democrats stood a very real chance of losing their congressional majority. The debate dragged on, with the vote deadlocked. The senators were testy, eager to dispose of this issue and get back home to campaign. The session was held over until Monday, September 30. On that day, President Wilson finally appeared on the Senate floor to make the unqualified speech for suffrage the women had been hoping for. He made all the right arguments. He offered his own wordy version of deeds not words: "If we be indeed democrats and wish to lead the world to democracy, we can ask other people to accept in proof of our sincerity and our ability to lead them wither they wish to be led nothing less persuasive and convincing than our actions." He reminded the senators of the wartime sacrifices of American women. "We have made partners of the women in this war; shall

Lucy Branham preparing to burn Wilson's words. *Library of Congress.*

we admit them only to a partnership of sacrifice and suffering and toil and not to a partnership of privilege and of right?" He made it very clear that suffrage was a wartime measure. "I tell you plainly that this measure is vital to the winning of the war and to the energies alike of preparation and of battle." He cast women's political contributions as valuable. "Without their counselings we shall be only half wise." It was a great speech. It didn't change a thing. On October 1, the amendment failed to reach a two-thirds majority by two votes, 62–34. And the Sixty-Fifth Congress recessed until December.

Now that the president had finally, publicly, given his unequivocal support to the amendment, the NWP planned regular pickets at the Senate instead. The banners were not subtle. One read, "Germany has established 'equal, universal, secret, direct franchise.' The Senate has denied equal, universal, secret suffrage to America. Which is more of a democracy, Germany or America?" Some of the banners called out individual senators: "Does Idaho want a senator who votes to place the United States behind Germany as a democracy?" The Capitol police and the pickets played a cat-and-mouse game for a few weeks. The police would keep the women in a holding room for a while, but they resumed their pickets as soon as they were released. So the police started holding them later in the

day. A federal judge ruled they couldn't be held without being charged, so the police allowed them to march but confiscated their banners. The judge made them give the banners back.

But Washington, D.C., wasn't the best place to influence a national election. The women needed to be out across the nation, campaigning in swing states and organizing newly enfranchised women. The NWP had planned another special train tour, this one called the "Prison Special," sending the veterans of Occoquan, dressed in their hated prison garb, around the country to make speeches and raise money. It was another tactic borrowed from the Pankhursts' British suffrage campaign; WSPU members regularly made speeches in their distinctive Holloway uniforms. But national travel was severely limited that fall by an unforeseen enemy: the Spanish influenza epidemic. The nation's hospitals were already understaffed, with so many doctors and nurses serving in the war. As thousands of Americans fell sick, public meetings were canceled and public buildings were closed. Towns placed restrictions on how many people could gather in one place, and some sealed themselves off entirely. It was not possible to launch a massive national campaign. The women would have to be strategic instead.

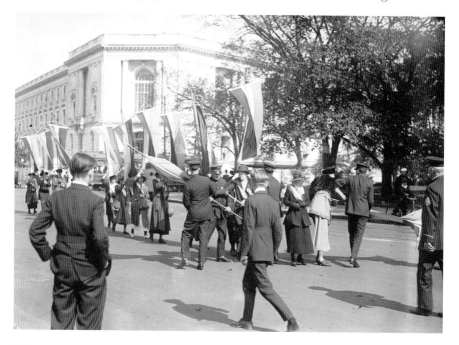

Police confiscating banners in front of the Senate office buildings. *Library of Congress.*

Two open Senate seats, one in New Hampshire and one in New Jersey, offered a chance to tip the Senate vote. Both happened to be contested by a pro-suffrage Democrat and an anti-suffrage Republican. Surely the president could be persuaded to help elect his fellow party members, especially in his home state of New Jersey. But the president seemed reluctant to use his influence, despite his eloquent words to the Senate. On Election Day, November 5, the Republicans won both seats.

But there was good news aplenty in the election results of 1918. Suffrage had passed in Michigan, Oklahoma and South Dakota, though it had failed in Louisiana. With a new Republican majority, suffragists could count on victory in the next House of Representatives. Even the new Senate, by lobbyist Maude Younger's count, would pass the amendment by a vote or two. Things were looking up. A week later, more good news arrived. On November 11, World War I finally ended. Americans across the country erupted in spontaneous celebration. In Washington, Wilson gave a speech outlining the terms of the armistice. It was a time to celebrate victory, and the NWP was swept up in the mood. Alice Paul gave a speech of her own and published the text in *The Suffragist*: "At this very time a year ago, we were eighty votes short of a favorable vote; this time a year ago, both majority parties believed suffrage should come state by state; this time a year ago the President believed suffrage should be won by the states, and this time a year ago suffrage was not before either the House or the Senate as a practical political subject." Now they had the president's support and the amendment had passed the House and fallen just shy in the Senate. The incoming Republican Sixty-Sixth Congress would almost certainly pass the amendment in both houses. So why even try again for the Sixty-Fifth when it reconvened for a lame-duck session in December? Why should suffragists kill themselves to win those final two Senate votes in the next four months instead of waiting for easy passage in May when the new Congress would take power? The answer had to do with timing after passage. If the amendment passed and was sent to the states in late 1918 or early 1919, the vast majority of state legislatures would still be in session and would be able to ratify the amendment quickly. If the amendment wasn't passed until May or later, almost all of the legislatures would be adjourned. That meant suffragists would have to convince governors to convene special sessions in each state before they even had the chance to convince the legislators to ratify. If the women wanted to be sure that national suffrage was the law of the land by the 1920 election, the final session of the Sixty-Fifth Congress might be their last, best chance.

The session started on a hopeful note. The NWP had been asking the president to include suffrage in his opening address to Congress in every session since 1913. This time, he did, extolling the virtues of American women: "The least tribute we can pay them is to make them the equals of men in political rights, as they have proved themselves their equals in every field of practical work they have entered, whether for themselves or their country." But that was where his efforts stopped. No lobbying, no horse-trading, no back-room deals with recalcitrant senators. Once again, Wilson had offered only words. And then he left town, off to France to attend the Peace Conference. Once again, the chairman of the Senate Rules Committee felt no pressure from the president and refused to schedule a vote on the amendment.

On December 16, another long line of white-clad women marched from NWP headquarters to the Lafayette statue. This time, only half of them carried purple, white and gold banners. The other half carried flaming torches. They placed a Grecian urn filled with pine logs at the base of the statue. They set the logs alight. One by one, women came forward and dropped papers containing Wilson's speeches into the fire. Every word the president had ever uttered on the subject of freedom was consigned to the flames. Then the women silently processed back to Jackson Place, where they hoped 1919 might bring more success.

On New Year's Day 1919, suffragists again carried the urn of logs out of their headquarters, this time heading for the White House sidewalk. They carried extra wood and a new banner that read, "President Wilson is deceiving the world when he appears as the prophet of democracy. President Wilson has opposed those who demand democracy for this country. He is responsible for the disenfranchisement of millions of Americans. We in America know this. The world will find him out." For five days, the women kept their "watchfire of freedom" burning day and night. Wilson was giving lots of speeches on the value of freedom at the Paris peace talks, so there were always new words to burn. Occasionally, policemen or angry spectators would try to kick over the fire, but the women always managed to relight it. Finally on January 5, the police began making arrests. Once again, the government attorneys could not figure out exactly what law the women had broken. They finally unearthed an old statute prohibiting the building of fires in a public place between sunset and sunrise. Undeterred, the women kept the watchfire burning, rejoicing when they saw their exploits had been covered in the Parisian press. Throughout January, a couple of dozen women were arrested for overnight fire building and

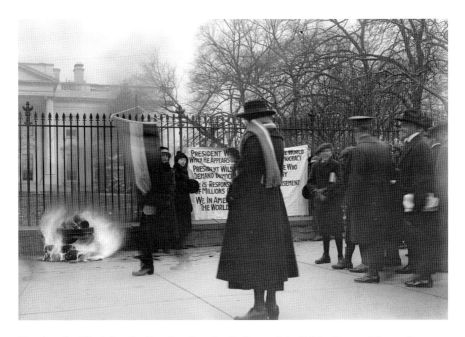

Keeping the Watchfires for Freedom burning in front of the White House. *Library of Congress.*

sentenced to five days in the District Jail. Many were arrested several times. The process became routine.

On February 3, the Rules Committee chairman changed his mind and scheduled a vote for February 10. Congress was scheduled to recess on March 3. Senator Pollock of South Carolina announced his intention to shift his support in favor of suffrage, leaving the amendment just one vote shy of victory. The day before the vote, one hundred white-clad women, in what was now a familiar sight, marched to the White House with banners and an urn full of wood. This time, instead of burning the president's words, they burned the man himself, via an effigy consisting of a sketch of Wilson from *The Suffragist*. Thirty-nine women were arrested. The rest stood guard over the fire until nightfall.

The next day, the Susan B. Anthony Amendment was again introduced on the Senate floor, with speeches limited to one from each side. With the fervor of a convert, Senator Pollock spoke eloquently on its behalf. He described himself as a spokesman for the "new south." "We want this privilege," he asserted. "We feel that women are entitled to it, and we know that we can handle any race question that comes up in this enlightened age." The anti speech also came from the South, when Louisiana's Senator Gay stated

forcefully that suffrage was a matter for the states to decide for themselves. The amendment lost by one vote. The chance to pass it in the Sixty-Fifth Congress was over. A last-ditch compromise designed to win over Senator Gay never came to a vote. The Sixty-Sixth Congress, with its Republican majority, wouldn't meet until May.

By mid-February, the flu epidemic had waned enough that it was safe to launch the "Prison Special" train tour. Dressed in their hideous, itchy dresses, the women steamed out around the country, describing their experience to fascinated crowds. In town after town, the erstwhile prisoners recounted the painful ordeal they had endured, simply for demanding the vote. In front of each overflowing hall, they laid the blame squarely at the feet of President Wilson, who was still in France. He was scheduled to return on February 24, landing in Boston. The suffragists were waiting for him there with banners and flags. The apologetic Boston police force removed them before the president arrived. As Stevens describes it, "The women were arrested in an exceedingly gentlemanly manner. But the effect on the crowd was electric. The sight of women being put into police wagons seemed to thrill the Boston masses much more than anything the President subsequently said in his speech." The women were held overnight and then tried the next day and convicted of loitering. But a "man of mystery," Mr. E.J. Howe, stepped forward to pay all the women's fines. No one knew who he was or why he financed this enterprise, but his actions saved Boston from potential embarrassment, which was probably his purpose.

The pickets were not treated so gently a week later in New York. On March 4, Wilson was scheduled to give a speech at the Metropolitan Opera House defending the proposed League of Nations. Twenty-five women with banners marched toward the Opera House, intending to stand across the street and then burn Wilson's speech. They were set upon by policemen before they reached the corner. "They said not a word but beat us back with their clubs," explains Stevens, "with such cruelty as none of us had ever witnessed before." And this was a group that had seen plenty of cruelty. Battered and ragged, five women were dragged to the police station and charged with assaulting the police. But then, inexplicably, they were released. They returned to the Opera House, where the conflict was still raging. Elsie Hill had managed to reach a balcony above the crowd and shouted down, "Did you men turn back when you saw the Germans coming? What would you have thought of anyone who did? Did you expect us to turn back? We never turn back, either, and we won't until democracy is won!" It was a far cry from the silent sentinels who had started the pickets more than two years

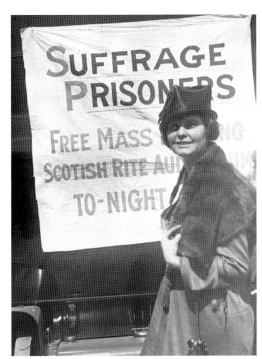

Right: Lucy Branham with a poster advertising the Prison Special. *Library of Congress.*

Below: The Prison Special in California. *Library of Congress.*

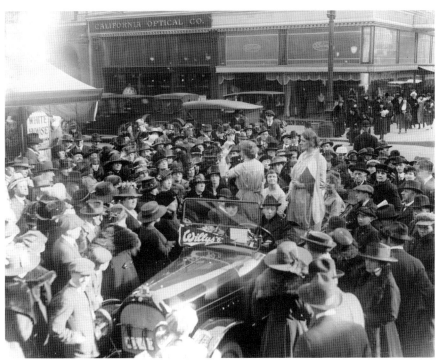

earlier. Eventually, the crowd was broken up, and the women returned to the New York headquarters. It would turn out to be their final picket.

With the president back in France and the Congress in recess, there was not much for the NWP to do. It raised money, always in short supply. An April nose count showed the amendment again short in the Senate. The lobbyists went to work, canvassing the new senators, pinning down the wafflers and unknowns, ensuring they had enough votes for passage. The president finally did his part, tracking down a vacationing senator in Italy, inviting him to Paris and getting him on the record in favor of suffrage. The women began, in earnest, to look beyond Congress and form a strategy for state-by-state ratification.

But first, the new Congress had to vote. On May 19, the Sixty-Sixth Congress convened for the first time. The next day, Wilson cabled from Paris in favor of the amendment, singling out the "women and men who saw the need for it and urged the policy of it when it required steadfast courage to be so much beforehand with the common conviction." It was the closest thing to an acknowledgement the NWP would ever receive from him. The president called for "immediate adoption" of suffrage. The new Republican

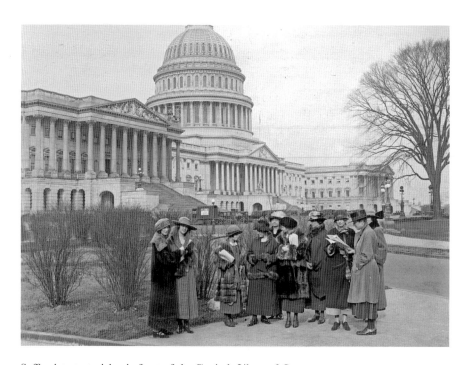

Suffragists strategizing in front of the Capitol. *Library of Congress.*

New members of the Sixty-Sixth Congress pose at the Capitol. *Library of Congress.*

majority, eager to earn popularity with the inevitable tide of women voters, scheduled the House vote for the very next day. It sailed through with forty-two more votes than it needed.

As the Senate vote neared, the Democratic National Committee, unwilling to let the opposing party claim all the glory, passed a resolution. It called on states to convene special legislative sessions to ratify the amendment as soon as it was passed in Congress, to "enable women to vote in the national elections of 1920."

The Senate took up the debate on June 3. Two surprise alternative amendments were defeated: one would have limited the franchise to white women, the other would require state conventions to ratify the amendment instead of state legislatures. On June 4, the amendment was finally put to a vote. As the roll was called, the suffragists kept running tallies in the galleries. By the time Senator Watson cast his vote in favor, they knew victory was theirs. The amendment passed with two votes to spare. On June 4, 1919, the Susan B. Anthony Amendment, first introduced forty-one years earlier, was finally submitted to the states for ratification.

The next day, newspapers across the country led with the news. The *Atlanta Constitution* ran a giant headline across the entire front page: "Political

Chains Stricken from Women after Battle that Lasts Forty Years." "Suffrage Wins in Senate; Sent to States," read the headline in the *Chicago Tribune.* "Illinois Has Chance to Be the First to Ratify." Under the heading "Women Who Engineered Suffrage Congress Victory," the *Washington Times* ran two separate photos, one of NWP leaders and one of the key members of NAWSA. Even the *New York Times*, which had editorialized against suffrage for years, conceded defeat: "To the National American Woman Suffrage Association, so ably and so subtly led by Mrs. Carrie Chapman Catt, the gold pen with which the golden resolution was signed in the senate was given in just testimony of the skill, the sagacity, and the habitual moderation of the majority feminist organization. Yet the National Women's Party, bolder, more original, implacable, should have been honored, shall we say, by a brass inkstand? In the hands of determined women a full card index of politicians is mightier than pen or sword." With that, the fight for ratification began.

Chapter 5

RATIFICATION

1919–1920

In 1919, the United States included forty-eight states. With a three-fourths majority required for the ratification of a new constitutional amendment, the women needed to find thirty-six states to make universal suffrage the law of the land. In the week after the June 4 Senate vote, Illinois, Michigan and Wisconsin raced to be the first states to ratify. All three states passed the measure on June 10, with Wisconsin edging out the other two for first place. Kansas, New York and Ohio ratified less than a week later, on June 16. The New York vote, while unanimous in both the state assembly and state Senate, previewed the issues suffrage supporters would face in later, harder battles. Both Democratic and Republican leaders tried to take credit for the amendment's passage and urged women voters to support their parties in return. The Socialist leader reminded both parties not to pat themselves on the back too hard. "Political suffrage is only a makeshift," August Claessens said. "[Women] want a voice in the industrial life of this nation." Senator Sage of Albany, a stalwart anti-suffragist, criticized the governor for pandering to women's votes with a special session, when the measure would pass easily when the legislature was scheduled to reconvene in January. In addition to unnecessary time and expense, Sage said, the amendment was "another instance of a certain number of people in the State of New York trying to force their will on a good many people in other states who have not accepted woman suffrage, just as we had not accepted prohibition when the federal amendment came before us."

The challenge of calling special sessions was one Alice Paul had foreseen, and it was every bit as frustrating as she expected. The roadblocks varied state by state and didn't necessarily correspond to whether a given state had women's suffrage already. In North Dakota, for instance, many of the legislators were farmers and simply couldn't participate until after the potato harvest. The potatoes, not caring much about politics, might ripen anytime between mid-September and the end of October. The governor of California had his own reasons for avoiding a special session. He saw legislative opponents organizing to repeal some measures he supported and didn't want to give them the chance any sooner than he had to. In Vermont, the governor objected to the ratification process itself. In his view, a new constitutional amendment should be a matter of public vote, not legislative action, and he refused to call a special session on principle.

The stubbornness of Connecticut's governor was particularly confusing, especially since the state legislature was clearly pro-suffrage. He denied suffragists' demands for a special session on five separate occasions, never providing justification for his decision. Little by little, politically connected NWP members figured it out. Connecticut senator Frank Brandegee was leaning heavily on the governor to delay the ratification vote, backed by a powerful railroad lobby, for whom he had provided many political favors. Brandegee was also one of the most outspoken anti-suffragists in the U.S. Senate. In May 1918, while World War I still raged, he had taken to the Senate floor to tell women, "Instead of bleating around here about their saving democracy by forcing their way into caucuses and conventions, they had better go home and knit bandages and pick lint and get ready to take care of their brothers and sons and fathers who are going to be shot to pieces in the trenches abroad." The chair of the Connecticut chapter of the NWP compared him to antique furniture: "interesting to observe, but not for present day use." If women got the vote, Brandegee had real reason to fear he'd be sent home to pick lint himself. And the railroads feared they'd lose a valuable ally

These state-by-state battles were expensive, time consuming and not what the NWP was best at. Its single-minded focus on the federal amendment had the side effect of allowing state politics to languish. NAWSA had much better state-level organizations and now brought them to bear on the ratification process. Finally, the two organizations were working toward a common goal with a common strategy. They still didn't have many nice things to say about each other but were no longer actively warring.

By the end of June 1919, Pennsylvania, Massachusetts and Texas had ratified the amendment, bringing the total to nine. Iowa, Missouri and Arkansas followed in July, but Georgia rejected ratification, the first state to explicitly do so. As described by the *Atlanta Constitution*, the arguments against the amendment included the familiar states' rights issue. Senator Jackson, when reminded that failure to ratify would lessen Georgia's influence with President Wilson and the Democratic Party, stated, "I care not for any appeal by Mr. Wilson on this issue. It transcends all matters of party. It is a question of states rights and of the vital interests of the people of our section. Mr. Wilson himself has had two views on the matter, having repeatedly declared that it was an issue for the states themselves to decide, and I prefer his first views to those adopted after mingling with the Bolsheviki of Europe." The senator went on to warn that women's suffrage would surely give too much power to black voters: "If you pass this nineteenth amendment you ratify the fifteenth, and any southerner, knowing what that means, is a traitor to his section." Supporters of the amendment spent a little time extolling the moral superiority of female voters. But mainly they worried that by voting down an inevitable measure, Georgia would be seen as benighted and lose national importance. As for the threat of "negro rule," Judge Covington

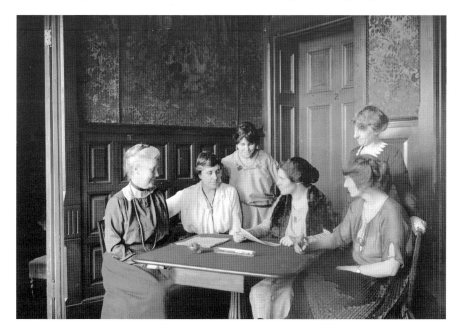

A ratification strategy meeting with Dora Lewis, Abby Scott Baker, Anita Pollitzer, Alice Paul, Florence Boeckel and Mabel Vernon. *Library of Congress.*

dismissed it with these words: "All this talk about Frederick Douglass and the fear of the negro woman voter is pure camouflage. Our present laws protect us from anything of that kind. I am willing to guarantee that when this amendment is adopted, as it surely will be, there will not be 300 negro women voters in the state of Georgia for the next twenty-five years." At the time, Georgia had over a million black citizens.

Throughout August and September 1919, four more states ratified the amendment: Montana, Nebraska, Minnesota and New Hampshire. Alabama rejected it. Then on October 1, President Wilson suffered a debilitating stroke. For a month, he had been crisscrossing the nation by train, giving ten speeches a day, shaking thousands of hands, to drum up support for the League of Nations. He hadn't collapsed in front of a crowd, so the only people who knew the full extent of his incapacity were his wife, his doctor and his secretary. The details were kept from the public—even from the congressional leadership. When Wilson's signature on some key pieces of legislation looked unfamiliar, a rumor began to spread of a "petticoat government" run by the first lady. Mrs. Wilson denied it, but it was more or less true. As the state legislatures debated the role of women in American politics, they had no idea how much power a woman currently held in the White House.

And the debates went on. Utah ratified in October. California's governor finally scheduled a vote in November, as did Maine. With the potato harvest safely in, North Dakota, South Dakota and Colorado ratified in December. By the end of 1919, half of the states had voted on the Susan B. Anthony Amendment, twenty-two for it and two against. Every time a state came through, Alice Paul sewed a star on a massive ratification banner at NWP headquarters.

In January 1920, a new challenge arose as the Eighteenth Amendment, Prohibition, took effect. The suffrage and temperance movements had been loosely affiliated for years as each tried to pass a constitutional amendment. In the nineteenth century, the temperance movement was the better-funded and better-organized partner, so it was useful to the suffragists to let Prohibition advocates believe women voters would support them. Many did, of course, although if the number of women who flocked to speakeasies during Prohibition is any indication, there was a diversity of opinion on this issue among female voters. In the twentieth century, suffrage groups began distancing themselves from the temperance movement, worried the association would cost them the support of male voters. But when Prohibition became the law of the land on January 16, suffragists paid the price for

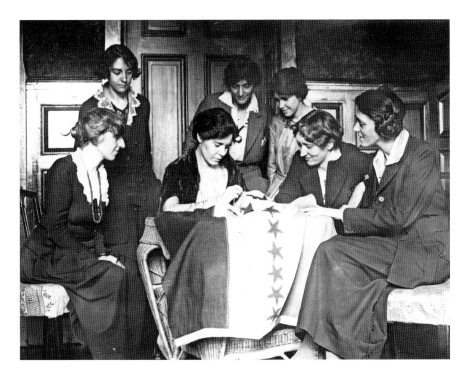

Alice Paul sews a star onto the ratification banner. *Library of Congress.*

making enemies of the liquor lobby. The "wets" had lost the Prohibition amendment but now focused on limiting its scope. Female voters would not help their cause, and they used whatever influence and organization they had to delay or block suffrage. As Senator Sage had previewed in New York six months earlier, anti-suffragists capitalized on Prohibition's unpopularity by conflating the two issues. James Nugent, the Democratic leader of New Jersey, said Prohibition and suffrage were "forced through an effeminate absentee congress of cowards by coercion and intimidation." He was quoted in the *Reno Gazette-Journal*, in an article placed, with no apparent intentional irony, directly under a short blurb about a man dying after drinking bootleg whiskey laced with wood alcohol.

Yet the ratification votes kept coming throughout January and February, as many regularly scheduled state legislative sessions were called to order. Kentucky, Rhode Island, Oregon, Indiana, Wyoming, Nevada, Idaho, Arizona, New Mexico, Oklahoma and, despite Nugent's best efforts, New Jersey brought the state total to thirty-three. South Carolina, Virginia and Maryland all voted against. Of the ten states left to vote, the suffragists

only needed three. But there were no easy targets left. The governors in Connecticut and Vermont were still refusing to hold votes. Mississippi, Florida, North Carolina, Louisiana and Tennessee were likely to vote against ratification, as the rest of the southern states had done. All attention turned to Washington, West Virginia and Delaware.

Washington was the only suffrage state of the ten remaining. Governor Louis Hart waffled on whether to call a special session. Hart had only been in the job for a few months, stepping in when Governor Lister retired early in poor health. Hart was facing reelection in November and really, really didn't want to face a potentially hostile legislature before he had to. At one point, he announced he would call a special session, only to renege. He claimed he only made the announcement hoping to pressure other governors into convening their own legislatures. He told the *Seattle Star* he did not trust the legislators to "keep their word to ratify suffrage and then quit, they will spend millions of dollars of state cash in useless appropriations." This game of chicken dragged on until March, when Hart bowed to the view that Washington

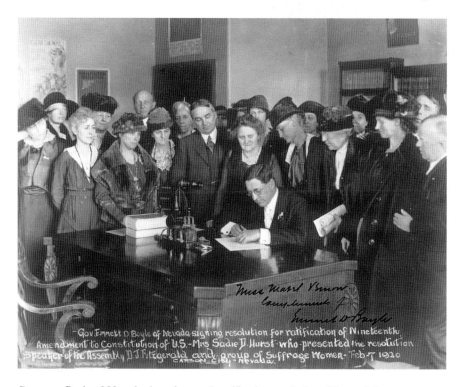

Governor Boyle of Nevada signs the state's ratification resolution. *Library of Congress.*

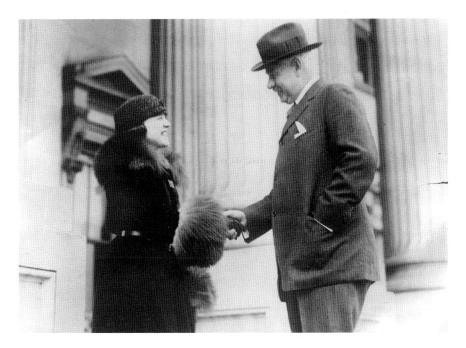

Senator Frelinghuysen congratulates Betty Gram on New Jersey ratifying the Nineteenth Amendment. *Library of Congress.*

could lose its national reputation as a progressive example if it waited for others to ratify. On March 22, the amendment passed unanimously.

West Virginia was much more of a nail-biter. After several failed attempts, suffrage had passed the state legislature in 1916, only to be trounced 2–1 in a statewide referendum. Suffragists blamed at least part of that loss on the powerful liquor lobby. In February 1920, Governor John Jacob Cornwell called a special legislative session to consider a tax question. Anti-suffragists leaned on him not to include ratification in the session, but Cornwell ignored them. The House of Delegates ratified quickly, sending the measure to the state Senate. There the vote deadlocked 14–14. It looked like the suffragists had lost. Then Senator Jesse Bloch, on vacation in California, sent a telegram to suffrage leader Lenna Lowe Yost saying, "Just received notice of special session. Am in favor of ratification." If the Senate could manage not to adjourn, Bloch promised he would get to Charleston to vote as soon as possible. The story that he boarded the train still in his bathing suit is, sadly, apocryphal. In that era, a trip from the Pacific coast to the mountains of West Virginia could take a while, so the Senate suffrage supporters dug in. Essentially holding half the Senate hostage, the fourteen senators in favor

of the amendment refused to end the session. The *Charleston Daily Mail* was incensed, calling the standoff "a ripper action" that "is not only a wicked perversion in the present issue, but promised untold evils for the future." Bloch sent regular telegrams updating his progress as he made his slow way across the country. By March 6, he was nearing Chicago and hoped to be in Charleston in two or three days. Meanwhile, the fourteen no votes tried a Hail Mary pass of their own. Anti-suffrage senator A.R. Montgomery had resigned eight months earlier and moved to Illinois. He asked Governor Cornwell to return his letter of resignation and reseat him in the state Senate. The governor refused. Senator Bloch finally arrived on March 10 and asked the Senate to reconsider the motion. This time, it passed.

With only one state to go, all eyes turned to Delaware. Governor John Townsend called a special session for March 22. As organizers from both sides overwhelmed the tiny state, letters and telegrams poured in to Governor Townsend. The *Wilmington News Journal* quoted one letter from a farm wife in neighboring Maryland, urging the governor to stand up to the anti-suffrage lobby. "It wasn't because we women of Maryland did or did not want citizenship that defeated the amendment here, it was the 'wet' forces. We are ashamed of our Legislature." A prominent suffragist quoted in the next column predicted, "Delaware was loyal to America in 1776. She will be loyal to America in 1920. She will prove her loyalty by her action in the historic state house at Dover, whose walls witnessed the birth of the first state of the Union, and will witness the birth of justice to the daughters of the Union." Ratification looked like it would probably pass the state Senate, but the House was looking ominous. A sizable anti-Townsend faction didn't want to hand the governor a victory on any issue, even one they supported. The lobbyists went to work. As the *News Journal* described it, "Throughout Delaware champions wearing the yellow and purple colors of the suffragists, and the red roses of the opposition were engaged with special pressure on members of the lower legislative branch, which so far has maintained a majority against ratification." The suffragists clearly saw Delaware as their best hope to ensure the vote before the 1920 election, although they certainly had a Plan B in mind. As they canvassed the state, the paper claimed the women were "seeking special session of the Connecticut and Vermont legislatures and counting on action at the North Carolina Assembly called for July. But Delaware remains their hope major for effecting ratification of the amendment in time to assure nationwide suffrage in the coming primaries." It was not to be. The Senate passed ratification 11–6, but the House trounced it, 26–6. The next months brought two more no votes, from

Mississippi and Louisiana. The final ratification would have to come from northern holdouts Vermont or Connecticut or from the unlikely southern states of North Carolina, Florida or Tennessee. Alice Paul watched her dreams of nationwide suffrage in 1920 fade away.

But of course, the 1920 election continued on regardless. In June, the Republicans held a convention in Chicago, where, after ten ballots, they nominated Ohio senator Warren Harding. Massachusetts governor Calvin Coolidge was nominated for vice president. Holding the party responsible for the stubborn Republican governors in Connecticut and Vermont, NWP members picketed the convention with banners reading, "Vote against the Republican Party as long as it blocks suffrage." Another sign read, "Republicans, we are here. Where is the 36th state?" Harding had never been a particularly vocal supporter of suffrage, but he knew the value of courting a huge new electorate. After the NWP pressed him to take a public stand and threatened to picket a campaign event, he issued a statement: "For myself and the Republican Party I earnestly desire that ratification may be accomplished in time to give the whole body of American women the ballot

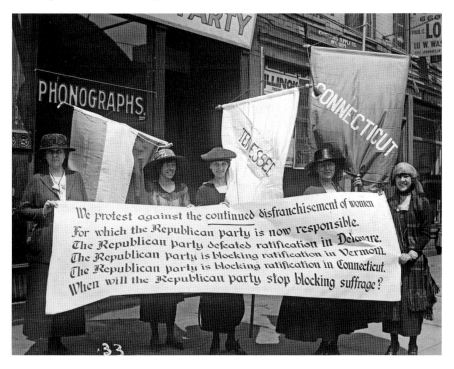

Picketing the 1920 Republican convention. *Library of Congress.*

next November. I am wearied with efforts to make partisan advantage out of the situation. I hope there will be ratification, and I don't care a fig whether it is secured through a Republican or Democratic State." He also invited suffragists to meet with him at his Ohio farm, which they did on July 22.

The Democrats convened in San Francisco on June 28. Their field was even more unsettled than the Republicans'. Despite his failing health, President Wilson held out a faint dream that his party would beg him to return for a third term. At the very least, he hoped to act as kingmaker for his successor. William Jennings Bryan, the losing candidate in the elections of 1896, 1900 and 1908, was also plotting a political comeback. After fully forty-four ballots, the party nominated Ohio governor James Cox, with Franklin Roosevelt as his running mate. Cox had supported suffrage in Ohio and pledged to continue his backing on a national level. He praised female voters, saying, "Their intuition, their sense of the humanitarian in government, their unquestioned progressive spirit will be helpful in problems that require public judgment. Therefore they are entitled to the privilege of voting as a matter of right and because they will be helpful in maintaining wholesome and patriotic policy." He also met with suffrage leaders in July in Ohio.

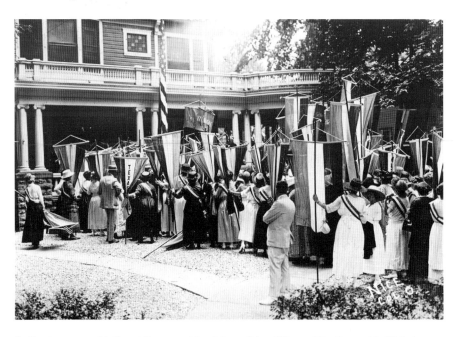

Suffragists meet with Republican presidential candidate Warren Harding at his Ohio home. *Library of Congress.*

Suffragists meet with Democratic presidential candidate James Cox. *Library of Congress.*

In addition to the two presidential nominees, the national press focused on Ohio in the summer of 1920 for another reason. The state legislature had ratified the Nineteenth Amendment back in June 1919. But Ohio's constitution included a provision that if 6 percent of Ohio voters requested a referendum within ninety days of legislative action, the matter could be put to a statewide vote. The issue could potentially be on the ballot in November. This process had already been triggered with the Eighteenth Amendment, Prohibition. The legislature ratified, 6 percent of voters requested a referendum and the Ohio secretary of state began printing ballots for the referendum. A Prohibition supporter sued for the process to stop, claiming it was an unnecessary use of state funds and a violation of Article V of the Constitution, which specifically requires state legislatures to ratify constitutional amendments. The Ohio Supreme Court upheld the referendum. By the summer of 1920, the case, known as *Hawke v. Smith*, had made its way to the U.S. Supreme Court, with the similar circumstances of the Nineteenth Amendment tacked on as a secondary case. On June 1, the Supreme Court handed down a unanimous decision: only the state legislature could ratify constitutional amendments. The referendum process was invalid. The text of the decision was unequivocal: "The framers of

the Constitution might have adopted a different method. Ratification might have been left to a vote of the people, or to some authority of government other than that selected. The language of the article is plain, and admits of no doubt in its interpretation. It is not the function of courts or legislative bodies, national or state, to alter the method which the Constitution has fixed."

Such clarity from the court immediately changed the prospects of ratification in the remaining states. Suffrage supporters had worried they might need to secure more than thirty-six states, to act as insurance against possible referenda in Ohio and Oklahoma, which had a similar state law. Now that possibility was off the table—the thirty-sixth state really was the finish line. The ruling also brought Tennessee back into play. Suffragists had dubious prospects for success there, not just because of Tennessee's southern culture but also because state law required one legislative election to pass after an amendment left the Congress and before it was voted on by the Tennessee legislature. *Hawke v. Smith* rendered that provision illegal. With Connecticut and Vermont still in a holding pattern, Tennessee suddenly looked like the best chance for ratification before the 1920 election.

The new importance of Tennessee did not escape the notice of opposition forces. By early August 1920, the state was crawling with champions for both sides. Suffrage supporters wore yellow roses in their lapels, while the antis wore red. The local papers, inevitably, dubbed the fight the "War of the Roses." No fewer than six storefront headquarters opened in Nashville alone. Now that both national parties had named pro-suffrage presidential candidates, both conveniently located in nearby Ohio, the NWP leaned on them to rally local party members. Dividing the state up into thirds, the NWP sent Anita Pollitzer east, Betty Gram west and Sue Shelton White in the center. Carrie Chapman Catt, who had not been particularly visible since the amendment passed the U.S. Senate, sent detailed, if jaded, instructions to her Tennessee NAWSA organizers. "No matter how well the women may work," she warned, "ratification in Tennessee will go through the work and action of men, and the great motive that will finally put it through will be political and nothing else. We have long since recovered from our previous faith in the action of men based upon a love of justice." She encouraged the Tennessee women to create a Men's Ratification Committee, with at least one hundred members. As the session grew nearer, Catt herself moved in to the grand Hotel Hermitage in Nashville. There she witnessed members of the legislature disappearing into back rooms and returning roaring drunk, courtesy of the anti-suffrage

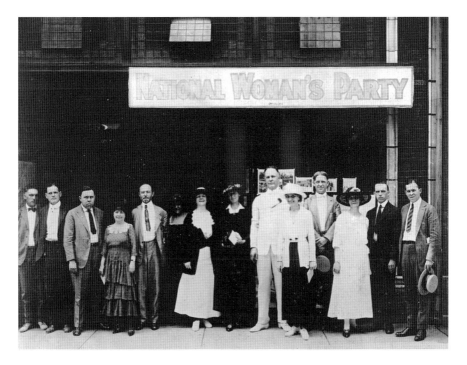

Supporters stand in front of the NWP headquarters in Tennessee. *Library of Congress.*

liquor lobby. Governor Albert Roberts, who had held off calling a special session until he was sure of his own re-nomination in the August 5 primary, called the legislature to order on August 9.

The first test came with the state Senate vote on August 13. Both sides expected it to be close, so everyone was surprised when ratification won by a lopsided 25–4. The debate had been ugly. Senator H.M. Candler, after warning the audience that suffrage surely meant "Tennessee would have negroes down here to represent her in the legislature" and that "negro men could marry white women without being socially ostracized," took a personal turn with his rhetoric. He accused suffrage supporters of bowing to "an old woman down here at the Hermitage Hotel whose name is Catt....Mrs. Catt is nothing more than an anarchist." Even the anti-suffrage *Nashville Tennessean* was somewhat taken aback by this vitriol. In a classic understatement, the paper reported, "The speaker was given to understand by the hisses of the audience that his remarks were ill-received and very offensive." Catt herself was clearly at the end of her patience. She wrote to a friend, "We are up to our last half a state....It is hot, muggy,

nasty, and this last battle is desperate. Even if we win, we who have been here will never remember it with anything but a shudder!"

Now attention turned to the Tennessee House. President Wilson sent a telegram to House Speaker Seth Walker, encouraging him to lead the House to ratification. But Speaker Walker, once a suffrage supporter and founding member of the Men's Ratification Committee, had mysteriously become its most vocal opponent. Rumors flew that he had succumbed to the charms of the railroad lobby, which had promised him free train passage, among other perks. Betty Gram confronted Walker in the Hermitage lobby and demanded, "What brought about your change, the Louisville & Nashville Railroad?" When the story of Gram's nerve got around, rumor had it that at least two pro-suffrage legislators promptly proposed marriage. The vote in the House looked excruciatingly tight. NAWSA and NWP members joined forces to make sure their supporters didn't leave town, get sick or change their minds. They invited the men to dinner, or to the movies, or for long drives in the country—anything to make sure they stayed in Nashville. The antis started distributing pamphlets reading, "Beware! Men of the South! Heed not the song of the Suffrage Siren!" Both sides took regular nose counts, but some legislators were confounding. What to make, for instance, of twenty-four-year-old Harry Burn, who wore a red rose in his lapel and was said to be a protégé of the boorish Senator Candler but told Anita Pollitzer, "My vote will never hurt you"? Or Jacob Simpson, who seemed to change his stance daily? One legislator even took to wearing his own unique boutonniere: a yellow rose with red edges. The dirty tricks got dirtier. Vote-buying prices rose. Legislators received fake calls telling them they had to go home for a family emergency. Pro-suffrage representative Joe Hanover received death threats and was ultimately given police protection.

On August 17, Representative Riddick of Memphis introduced the ratification measure. By mid-afternoon, Speaker Walker offered a motion to cut off debate and adjourn until the next morning. It passed 52–44. Harry Burn voted for it. Neither side knew what to make of the vote. On the one hand, the antis seemed to have enough votes to cut off debate. But if they were so sure of victory, why didn't they call a vote on the amendment itself? The answer would have to wait a day.

On August 18, the legislative chamber was packed. Red and yellow roses sprouted from lapels, hats and bodices. Suffragists cheered to see one supporter had returned from California and another had been released from the hospital following an operation. Ninety-six of the ninety-nine House

members were present and voting, but neither side was totally sure if they could claim support from forty-nine of them. Debate opened with all the familiar arguments. This back and forth had been going on for seventy-two years. Finally, with the confidence of certain victory, Seth Walker moved to table the motion. When the roll was called, Harry Burn voted to table the amendment. But he wavered. In his pocket he kept a letter from his mother, Febb Burn of Niota, Tennessee. She had been following news of the session in her local paper and was disappointed to see her son had not taken a public stand. "Hurrah and vote for suffrage!" she wrote. "Don't keep them in doubt. I have noticed Chandler's [sic] speech, it was very bitter. I have been watching to see how you stood, but have not noticed anything yet." She went on to cover family and neighborhood news but circled back to the suffrage issue: "Don't forget to be a good boy and help Mrs. Catt put the 'rat' in ratification."

The motion to table lost on a 48–48 tie, with a surprise no from Representative Banks Turner. Walker demanded a recount and hurried up to Turner for a quick whispered conference. Turner held firm, 48–48. But a tie would mean defeat for ratification itself, so Walker immediately called for a vote on the original motion. This time, when the roll call got to Burn, he switched his vote to a quiet "aye." A murmur of conversation spread through the hall. With Burn's support, the amendment would pass, as long as Turner continued to hold steady. When his name was called, Turner offered an enthusiastic "aye!" and the hall erupted. The Susan B. Anthony Amendment had been ratified by the Tennessee legislature, 49–47. Seth Walker quickly changed his vote to aye as well, since only a member voting with the majority could bring a motion to reconsider. But the effort was futile. By the time Walker called a reconsideration vote three days later, too many anti-suffrage votes had left the state to give the measure any chance. Ironically, Walker's last-ditch vote switch officially made the final tally

Mrs. Burn's letter to her son urges, "Hurrah and vote for suffrage." *Harry T. Burn papers, McClung Historical Collection.*

50–46, a much harder margin of victory to challenge in the courts for a 99-member House.

The next day, Nashville buzzed with rumors of how the vote was won. Did someone bribe Harry Burn? Was Seth Walker a secret suffragist who had engineered the whole process to ensure a fifty-vote victory? Burn himself tried to put the rumors to rest by taking to the House floor for a speech. "I know that a mother's advice is always safest for her boy to follow," he said. "And my mother wanted me to vote for ratification."

On August 24, Governor Roberts signed Tennessee's ratification and sent it by special delivery registered mail to Secretary of State Bainbridge Colby in Washington, D.C. A state department employee woke Colby up at 3:45 a.m. August 26 to deliver the packet. "I confess to a disinclination to signing it in the wee morning hours of the night," Colby told the *New York Times*, "believing that would not be conducive to a dignified function of so important a character, and thought that 8 o'clock in the morning would be a fair hour for action in the matter." At 8:00 a.m., Colby signed the proclamation in his home. No suffragists were present to witness this historic act. "It was quite tragic," said the NWP's Abby Scott Baker. "This was the final culmination of the women's fight, and women, irrespective of factions, should have been allowed to be present when the proclamation was signed." Alice Paul tried to convince Colby to re-create the moment in front of a movie camera, but he refused. According to the *Times*, "Asked whether he would give the pen to the National American Woman's Suffrage Association, the National Woman's Party, or send it to the Smithsonian Institution, Secretary Colby said with a smile, 'I should not be surprised if it found its way there.'" Today, the modest wooden fountain pen remains in the collection of the Smithsonian's National Museum of American History, although it is not regularly on display.

The disappointment of not being present at the moment of signing was forgotten under the sheer elation of finally, finally, winning the vote. Paul stitched the last star on her ratification banner and hung it from the balcony of the NWP's Jackson Place headquarters. States that supported suffrage scrambled to make sure women could register before the November general election. To that end, Connecticut's governor finally scheduled a special legislative session and ratified the amendment in September. States like Georgia that wanted to suppress female voters used the same short timeline to invalidate women's registrations, particularly those of black women. NAWSA renamed itself the League of Women Voters, a nonpartisan organization that still promotes active participation in government. After a soul-searching

Anita Pollitzer receives news of Tennessee ratifying the amendment. *Library of Congress.*

meeting at Alva Belmont's Long Island castle, the NWP decided to remain intact and dedicate its efforts toward equal rights for women.

The much-anticipated 1920 election rolled around on November 2. Over eighteen million more Americans showed up to the polls than had four years earlier. In the thirty-six states for which data is available, women generally made up 35 to 40 percent of the electorate. The six unavailable states are all in the South, where the numbers of female voters are assumed to be much lower. Warren Harding won in a landslide, a vote largely seen as a repudiation of Woodrow Wilson's Democrats. Women voters did not

vote substantially differently than their male counterparts, and established patterns of region, race and economic class held true. Before long, men who held female voters to a higher moral standard than they held themselves were publishing editorials that asked "Is Woman Suffrage a Failure?" Generally, these articles answered the question in the affirmative, as did Charles Edward Russell in 1924: "Not a boss has been unseated. Not a reactionary committee wrested from the old-time control, not a convention has broken away from its familiar towage. Nothing has been changed, except that the number of docile ballot-droppers has approximately been doubled."

Despite the patronizing commentary, the incontrovertible fact remained that women could now vote across the United States. The suffrage fight had been long and hard and filled with strategic missteps and unforeseen roadblocks. But the women had won. Never again would American women be told they didn't deserve this basic democratic right. The ratification of the Nineteenth Amendment didn't "grant" women the right to vote as if it were a new gift; as U.S. citizens, they had that right all along. The amendment simply acknowledged the facts.

Vermont ratified the Nineteenth Amendment in February 1921. While the measure was redundant, it ensured a comfortable margin of victory

Alice Paul unfurls the final ratification banner from the balcony of NWP headquarters. *Library of Congress.*

Anita Pollitzer and Alice Paul pay their respects at Susan B. Anthony's grave. *Library of Congress.*

if legal maneuverings threw out the razor-thin votes in West Virginia or Tennessee. Throughout the rest of the twentieth century, more states ratified the amendment long after it was the law of the land. The final ratification came from Mississippi, on March 22, 1984; 136 years had passed since Susan B. Anthony and Elizabeth Cady Stanton had first proposed women's suffrage at Seneca Falls.

EPILOGUE

After the promulgation of the Nineteenth Amendment on August 26, 1920, American women could no longer be denied the right to vote on account of sex. But they could still be denied the right to vote on other grounds, and they could still be denied other rights based on sex. To understand the limits of the amendment, it is worthwhile to repeat the text in its entirety:

> *The right of citizens of the United States to vote shall not be denied or abridged by the United States or any State on account of sex.*
> *Congress shall have power to enforce this article by appropriate legislation.*

For some women, their right to vote was restricted by the fact that, although they were citizens, they did not technically live in states. Such was the case for the women of Puerto Rico, whose residents were given U.S. citizenship in 1917. But since Puerto Rico is not a state, the legislature was able to legally deny voting rights to women. Other territories, like Hawaii, granted women the vote in 1920. But Puerto Rico refused. In 1929, the legislature allowed "literate" women to vote. Universal suffrage wasn't passed in Puerto Rico until 1935. This was strictly local legislation. Puerto Rican women, as U.S. citizens, would immediately gain the vote if they moved to a U.S. state. It wasn't their ethnicity that rendered them ineligible but their home address. A similar situation is still true for, among others, both male and female residents of Washington, D.C. While they were given the right

to vote for president in 1961, residents of the capital still do not have a voting representative in either house of Congress. If they move to a state, it immediately becomes illegal to deny that right.

Other women were denied the right to vote based on their citizenship status. Native American women who lived on reservations weren't considered citizens in 1920. Although the Fourteenth Amendment defined as citizens any person born in the United States, the amendment was interpreted to exclude tribal lands. Congress passed the Indian Citizenship Act in 1924, granting Native Americans full rights as U.S. citizens, including suffrage. However, individual states continued attempts to disenfranchise Indians well into the twentieth century.

Another group of women who were denied citizenship, and therefore the vote, were those who had immigrated from Asia. When suffrage passed in 1920, most Asian nations were part of the "barred zone" of prohibited immigration. Then the Immigration Act of 1924 introduced new quotas for immigrants based on national origin: the quota for Asian nations was set at zero. After World War II, a series of laws provided a path to citizenship for limited numbers of Asian immigrants from certain countries. The children of these immigrants, born in the United States, were automatically citizens under the Fourteenth Amendment.

Then there were women who technically had the right to vote but were subject to all kinds of restrictions and tests designed to limit that right. Since the passage of the Fifteenth Amendment in 1870, southern states had systematically instituted practices that severely curtailed the voting rights of African American men. These ranged from grandfather clauses, poll taxes and literacy tests all the way to outright violence. After the Nineteenth Amendment, African American women in the South became subject to all the same efforts. Poll taxes were eliminated by constitutional amendment in 1964, and the Voting Rights Act of 1965 outlawed literacy tests. Off-the-books intimidation and violence continued. Voting rights advocates today contend with more contemporary restrictions on suffrage: voter ID laws, limited polling place hours and reduced days available for voting.

For those American women who were able to exercise the right to vote, the Nineteenth Amendment did not confer any other rights. For instance, even though juries are selected from voter rolls, women were largely excluded from jury service. In 1920, only fourteen states allowed women to serve on juries. By 1942, when women were increasingly filling traditionally male roles, that number had only climbed to twenty-eight. Most of those states allowed women to request exemption from service based on their sex.

Women weren't included in jury service nationwide until 1973. Well into the late twentieth century, it was legal to restrict American women from certain jobs, pay them less than men for the same job, fire them if they got married or became pregnant, deny women credit, require married women to forfeit their property to their husbands and sexually harass women in the workplace. The Nineteenth Amendment only prohibited discrimination based on sex within the narrow context of voting.

Which is not to belittle the power of the vote. Recognizing their new influence, several women's groups joined forces to lobby for legislation they felt had been ignored by male voters. Carrie Chapman Catt's NAWSA, newly reconstituted as the League of Women Voters, joined the Women's Trade Union League, the National Consumer's League and several other groups to form the powerful Women's Joint Congressional Committee in 1920. One of their first successes was the Sheppard-Towner Act of 1921, officially known as the Promotion of the Welfare and Hygiene of Maternity and Infancy Act. As the wordy title indicates, the law provided federal funding for mother and child health.

Another early success for women voters was the Married Women's Independent Nationality Act, also known as the Cable Act of 1922. Previously, an American woman lost her citizenship if she married a foreign man, since she assumed the citizenship of her husband. The same was not true of American men who married foreign women. With the Cable Act, U.S. citizens of both sexes could retain their citizenship after marrying a noncitizen. However, the law only applied if the foreign spouse was eligible for naturalization in the United States. Since Asian immigrants were denied citizenship, women who married Asian men still forfeited their U.S. citizenship.

Women ran up against the limits of their new power in the fight for child labor laws. Throughout the Progressive era, several attempts were made to pass legislation restricting or regulating work by those under fourteen or sixteen. All were struck down by the courts as unconstitutional. So proponents decided to amend the Constitution. In 1924, with heavy lobbying from women's groups, Congress passed the Child Labor Amendment, giving itself the power to limit child labor. The amendment was ratified by twenty-eight states but fell short of the thirty-six needed for promulgation. Since no time limit was set, the amendment is technically still pending. However, the need for the amendment was largely obviated by the Fair Labor Standards Act of 1938, which did manage to win the approval of the Supreme Court.

After a few elections in the 1920s and 1930s, it became clear that women weren't voting as a bloc. It wasn't necessarily true, as some sneered, that women were voting the way their husbands and fathers told them to. It was more that classifications along socioeconomic, geographical and racial lines dictated voting patterns more than gender did. Male politicians began to fear the mythical women's vote less. The Sheppard-Towner Act, for instance, was defunded in 1929, despite having a demonstrable impact on infant and maternal health.

But the women who had fought for suffrage were not about to retire quietly. The members of the National Woman's Party decided not to disband, realizing their influence was still necessary to draft and lobby for women's legislation. They also decided, now that American women had secured the vote, they could have some influence internationally. In 1923, Alice Paul drafted the first version of the Equal Rights Amendment (ERA). It was introduced in every Congress for fifty years. Initially, the fiercest opposition to the ERA came from other women's groups, including the League of Women Voters. They had won special protections for female workers, including mandatory breaks and other health and safety measures. The ERA would negate those gains. It wasn't until men were also given those workplace protections, mainly under the Fair Labor Standards Act, that most women's groups more or less united behind the ERA. The amendment finally passed Congress in 1972. By then, Alaska and Hawaii had joined the Union, meaning thirty-eight states had to ratify for the amendment to become law. By the time the deadline passed in 1982, only thirty-five states had done so.

The former suffragists also worked to get more women elected to public office. Some, like Anne Martin, ran for office themselves. Others hit the campaign trail on their behalf. The number of women in Congress stayed in the single digits until World War II. The first female senator wasn't elected until 1932. Today, there are 104 women in the House of Representatives and 21 in the Senate, an all-time high for both houses.

The patron saints of the suffrage movement also occupy the U.S. Capitol. In 1921, one year after the ratification of the Nineteenth Amendment, the National Women's Party donated a massive sculpture called *The Portrait Monument* to the women of America. Sculptor Adelaide Johnson created the piece out of an eight-ton block of Carrara marble. Carved busts of Elizabeth Cady Stanton, Susan B. Anthony and Lucretia Mott rise up out of the massive marble block. Behind the three figures looms a rough-hewn lump of marble, still uncarved. Some say viewers are meant to imagine themselves in that space. Others claim it is waiting to be carved with the likeness of the

Alice Paul meets with the International Advisory Committee of the NWP, 1922. *Library of Congress.*

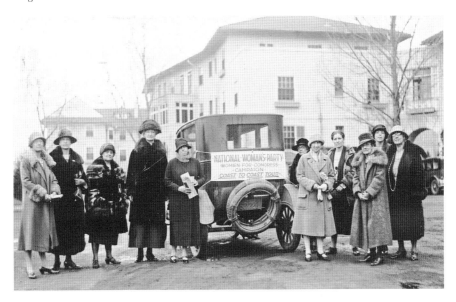

NWP members hit the campaign trail for women candidates, 1926. *Library of Congress.*

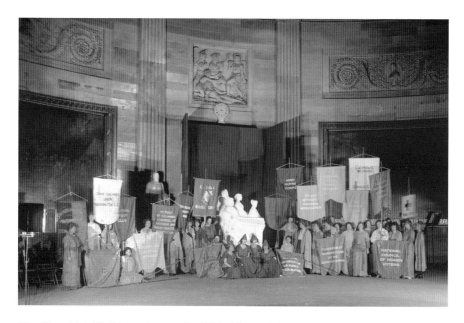

Unveiling Adelaide Johnson's statue in 1921. *Library of Congress.*

first female president. Sculptor Johnson considered the unfinished surface a
kind of unknown soldier of the women's movement, meant to represent how
many more women still needed to fight for the cause. On February 15, 1921,
the 101st anniversary of Anthony's birth, the statue was unveiled with great
fanfare in the Capitol Rotunda. It stayed there for exactly one day before
it was moved down to the crypt, essentially the Capitol's basement. It was
finally returned to the Rotunda in 1997, when Nancy Pelosi, the first female
Speaker of the House, had it moved back upstairs. It sits there still, where it
is affectionately known as "Three Women in a Tub."

When the National Woman's Party moved to the house it currently
occupies on Constitution Avenue, Alice Paul moved with it. She lived there,
fighting for the ERA, well into her eighties. She died in 1977 at the age
of ninety-two. She had been involved with the women's movement for
seventy years, since she first saw the Pankhursts speak as a graduate student
in London. Sixty-five years had passed since she dreamed up the Suffrage
March of 1913, imagining the costumes and colors and pageantry that
would capture the attention of a new president and the nation. Since then,
countless men and women have literally followed in her footsteps, marching
down Pennsylvania Avenue to bring their cause to the corridors of federal
power in Washington.

Suffrage Walking Tour

Washington, D.C., is a great walking town. It is largely flat, with a clear street grid and wide sidewalks. This entire walk is about two miles end to end and takes about three hours, depending on how long you linger at each stop. But if you don't want to walk the whole distance, the major points are easily accessible by Metro.

1. Belmont-Paul Women's Equality National Monument
144 Constitution Ave NE
www.nationalwomansparty.org
Metro: Union Station (Red line)

This house became the headquarters of the National Woman's Party in 1929 and still serves that purpose today. Inside, you will find a priceless treasure-trove of suffrage memorabilia and research, including the famous card file. You'll also see banners, sashes, capes and costumes galore. If you have the time and inclination, set up a research appointment to explore back issues of *The Suffragist* and the amazing scrapbooks many of the NWP members kept throughout the fight for the vote.

Belmont-Paul Women's Equality National Monument is located on Capitol Hill at the corner of Constitution Avenue and Second Street NE, next to the Hart Senate Office Building. It is a free-standing, Federal-style brick house surrounded by a black cast-iron fence. The entrance for museum tours and the museum shop is located on Second Street,

with the lift-accessible entrance also located on Second Street. The doors facing Constitution Avenue are not entrances. It is open 9:00 a.m. to 5:00 p.m. Wednesday through Sunday, with guided tours offered throughout the day. Admission is free.

2. Capitol Visitor Center
First Street and East Capitol Street
www.visitthecapitol.gov

You could definitely spend all day at the Belmont-Paul Women's Equality National Monument. But if you want to keep moving, head south on Second Street NE for one block, then take a right turn on East Capitol Street. The road ends at the east façade of the Capitol, which is where the visitor center is located. Inside, you will find a history of the Capitol and the U.S. Congress. You can also book a tour for the rest of the Capitol. Look for the statue of Jeannette Rankin in Statuary Hall and for Adelaide Johnson's *Portrait Monument* (aka Three Ladies in a Tub) in the Rotunda.

The Capitol Visitor Center, the main entrance to the U.S. Capitol, is located beneath the east front plaza of the U.S. Capitol at First Street and East Capitol Street. It is open 8:30 a.m. to 4:30 p.m. Monday through Saturday. Admission is free.

3. The Peace Monument
First Street NW and Pennsylvania Ave NW

Now it's time to walk the parade route. To get to the starting point, turn left out of the Capitol Visitor Center and walk counterclockwise around the Capitol to the west façade. At the northwest corner of the Capitol grounds, find the small traffic circle at the foot of Pennsylvania Avenue. The Peace Monument in the center is a white marble base topped by the figure of Grief weeping on the shoulder of History. This is where the women gathered on the morning of March 3, 1913, to prepare for the grand procession. The floats, bands and marchers stretched out behind the Grant statue all the way to the symmetrical traffic circle at the southwest corner of the Capitol grounds, where the Garfield monument stands. Ready to start marching? Imagine Jane Burleson, resplendent atop her horse, giving the signal to begin as you head northwest up Pennsylvania Avenue.

4. THE NATIONAL ARCHIVES
700 Pennsylvania Avenue NW
www.archives.gov
Metro: Archives/Navy Memorial (Green and Yellow lines)

The parade route travels a full fourteen blocks up Pennsylvania Avenue. If you want to break up the trip, stop in at the National Archives. In the rotunda, make sure to see the original U.S. Constitution and the Bill of Rights. Within the exhibit halls, you'll find lots of information on how hard it is to amend the Constitution. The original copy of the Nineteenth Amendment is sometimes on display, but even if it's not, you can pull up a digital copy in the interactive exhibits.

The research entrance to the building is on Pennsylvania Avenue. The rotunda entrance, which includes the Exhibit Hall, is on Constitution Avenue. The public exhibits are open from 10:00 a.m. to 5:30 p.m. Monday through Saturday. Admission is free.

5. FREEDOM PLAZA
Pennsylvania Avenue NW between Thirteenth Street NW and Fourteenth Street NW

Continue your march up Pennsylvania Avenue. As you walk, notice how wide the street is and how broad the sidewalks are. Now imagine that area so jammed with people that the marchers had to proceed single file. Freedom Plaza is a flat, paved park, with a map of Pierre L'Enfant's original plan for downtown Washington worked into its paving stones. It remains a popular place to hold protests. From the middle of the plaza, look back at the Capitol dome rising up at the foot of Pennsylvania Avenue. You have now walked right through the heart of federal Washington.

6. U.S. TREASURY DEPARTMENT
1500 Pennsylvania Avenue NW

Walk the final block of Pennsylvania Avenue and turn right on Fifteenth Street NW. The White House will be in front of you, but we'll get a better view of it next. Walk up Fifteenth Street to the imposing U.S. Treasury Department building. See the grand staircase on the south side of the

building, leading down to a broad terrace? That's where the tableaux were held on March 3, 1913. Grandstands lined that end of Pennsylvania Avenue to give VIP guests a front-row seat to the spectacle. Picture dozens of women and girls in togas waiting forever on the cold stone, hoping the parade would soon come by.

7. THE WHITE HOUSE
1600 Pennsylvania Avenue NW

Continue up Fifteenth Street NW, keeping the Treasury Department on your left. As you pass F Street NW, glance down the block. The Congressional Union's original basement headquarters at 1420 F Street NW were there, although the building is long gone. When you get to the back of the Treasury building, take a left into the pedestrian plaza part of Pennsylvania Avenue, which is blocked off to vehicle traffic. Walk one block down Pennsylvania until you are directly in front of the north gate of the White House. This is where the majority of the pickets of 1917 took place, as well as the watchfires of 1919. If you want to tour the White House, you must make a request well in advance through your local member of Congress. But anyone can stand outside the gate; in fact, you are almost guaranteed to see protesters as you walk by. Feel free to remind them that the idea of picketing the White House came from Alice Paul and the National Women's Party.

8. LAFAYETTE SQUARE
Bounded on the north by H Street NW, on the east by Madison Place NW, on the south by Pennsylvania Avenue NW and on the west by Jackson Place NW
Metro: McPherson Square (Orange, Blue and Silver lines)

Now turn around and face north, so the White House fence is at your back. The green space in front of you, crisscrossed by brick paths, is Lafayette Square. The equestrian Clark Mills statue in the center is of Andrew Jackson. There is a lot of fascinating history in Lafayette Square, but for our purposes, concentrate on Lafayette's statue in the southeast corner. This is where National Women's Party members burned Woodrow Wilson's words in 1918.

9. CAMERON HOUSE
21 Madison Place NW

From the statue, walk up the east side of Lafayette Square, along Madison Drive. Cameron House is the three-story building halfway up the block with a decorative iron balcony on the second level. Also known as the Benjamin Ogle Tayloe House, this building served as headquarters for the National Women's Party from the fall of 1915 until the Cosmos Club (which owned the building next door) bought it at the end of 1917. The Cosmos Club moved in 1952, and Cameron House, along with many other historic buildings along Lafayette Square, was slated for demolition in 1960. The Kennedy administration instead decided to preserve the buildings, join them together and incorporate them into the National Courts Building that looms behind. Cameron House, the original Cosmos Club building and the Cutts-Madison House on the corner remain part of the National Courts Building complex.

10. JACKSON PLACE HEADQUARTERS
722 Jackson Place NW

From Cameron House, turn around and walk through Lafayette Square to the opposite side. The row of brick houses along Jackson Place was where National Women's Party headquarters stood from 1918 to 1920. Sadly, the balcony where Alice Paul stood with the ratification banner is no longer there.

Be aware that occasionally, and with no warning, the Secret Service closes Lafayette Square and the north lawn of the White House for security reasons. Usually, they reopen it to pedestrians after just a short wait, but sometimes the closures last all day.

FARTHER AFIELD

These sights are too far to walk to but worth a visit.

HISTORIC CONGRESSIONAL CEMETERY
1801 E Street SE
www.congressionalcemetery.org
Metro: Stadium Armory (Orange, Blue and Silver lines)

Opened in 1807, Congressional Cemetery is the final resting place of pioneering lawyer Belva Lockwood, sculptor Adelaide Johnson and many women who participated in the 1913 march. You can download a walking tour of suffragist graves on its website. You can also see the site of the D.C. jail from the cemetery grounds. The current building is not the one where the picketers were imprisoned. The cemetery is open for self-guided tours from dawn to dusk. Admission is free.

OCCOQUAN WORKHOUSE MUSEUM
Building 9
Workhouse Arts Center
9601 Ox Road, Lorton, VA
www.workhousemuseums.org

The Occoquan Workhouse still stands but has been converted to the Lorton Arts Center. Several of the studios now host a museum dedicated to the stories of those imprisoned at Occoquan, with particular attention to the suffragists of 1917. As of this writing, a larger museum is planned in one of the abandoned dormitories. Occoquan Workhouse Museum is open from 12:00 to 3:00 p.m. Wednesday through Friday and 12:00 to 4:00 p.m. Saturday and Sunday. Admission is free.

BIBLIOGRAPHY

Adams, Katherine H., and Michael L. Keene. *Alice Paul and the American Suffrage Campaign.* Urbana: University of Illinois Press, 2008.

Atlanta Constitution. "Political Chains Stricken from Women after Battle that Lasts Forty Years." June 5, 1919.

Bland, Sidney R. "New Life in an Old Movement: Alice Paul and the Great Suffrage Parade of 1913 in Washington, D.C." *Records of the Columbia Historical Society, Washington D.C.* 71–72 (1971).

Bolt, Christine. "America and the Pankhursts." *Votes for Women: The Struggle for Suffrage Revisited.* Edited by Jean H. Baker. Oxford, UK: Oxford University Press, 2002.

Butler, Amy E. *Two Paths to Equality: Alice Paul and Ethel M. Smith in the ERA Debate, 1921–1929.* Albany: State University of New York Press, 2002.

Cahill, Bernadette. *Alice Paul, the National Woman's Party, and the Vote: The First Civil Rights Struggle of the 20th Century.* Jefferson, NC: McFarland & Company, 2015.

Chicago Tribune. "Suffrage Wins in Senate; Sent to States." June 5, 1919.

Clift, Eleanor. *Founding Sisters and the Nineteenth Amendment.* Hoboken, NJ: John Wiley & Sons, 2003.

DuBois, Ellen Carol. "The Next Generation: Harriot Stanton Blatch and Grassroots Politics." *Votes for Women: The Struggle for Suffrage Revisited.* Edited by Jean H. Baker. Oxford, UK: Oxford University Press, 2002.

———. *Woman Suffrage and Women's Rights.* New York: New York University Press, 1998.

Edwards, Rebecca. "Pioneers at the Polls: Woman Suffrage in the West." *Votes for Women: The Struggle for Suffrage Revisited.* Edited by Jean H. Baker. Oxford, UK: Oxford University Press, 2002.

Fawcett, Millicent Garrett. *Women's Suffrage: A Short History of a Great Movement.* London: Albion Press, 2015.

Ford, Linda G. "Alice Paul and the Politics of Nonviolent Protest." *Votes for Women: The Struggle for Suffrage Revisited.* Edited by Jean H. Baker. Oxford, UK: Oxford University Press, 2002.

———. *Iron-Jawed Angels: The Suffrage Militancy of the National Woman's Party, 1912–1920.* Lanham, MD: University Press of America, 1991.

Fort Wayne Sentinel. "Police Must Face Charges." March 4, 1913.

Fowler, Robert Booth, and Spencer Jones. "Carrie Chapman Catt and the Last Years of the Struggle for Woman Suffrage: 'The Winning Plan.'" *Votes for Women: The Struggle for Suffrage Revisited.* Edited by Jean H. Baker. Oxford, UK: Oxford University Press, 2002.

Harper, Ida Husted. *How Women Got the Vote: The Story of the Women's Suffrage Movement in America.* N.p.: Encyclopedia Americana, 1920.

Harvey, Sheridan. "Marching for the Vote: Remembering the Woman Suffrage Parade of 1913." *American Women: A Library of Congress Guide for the Study of Women's History and Culture in the United States.* N.p., 2001.

Jablonsky, Thomas. "Female Opposition: The Anti-Suffrage Campaign." *Votes for Women: The Struggle for Suffrage Revisited.* Edited by Jean H. Baker. Oxford, UK: Oxford University Press, 2002.

Kraditor, Aileen. *The Ideas of the Woman Suffrage Movement, 1890–1920.* New York: W.W. Norton, 1981.

MacPherson, Myra. *The Scarlet Sisters: Sex, Suffrage, and Scandal in the Gilded Age.* New York: Hachette, 2014.

McConnaughy, Corrine M. *The Woman Suffrage Movement in America.* Cambridge, UK: Cambridge University Press, 2013.

New York Sun. Editorial, June 20, 1917.

New York Times. "Angered by Insults to Women." March 10, 1913.

———. "Colby Proclaims Woman Suffrage." August 27, 1920.

———. "Federal Woman Suffrage." June 6, 1919.

———. "Her Pressure on Congress." March 2, 1919.

———. "Militants Get Three Days; Lack Time to Starve." June 18, 1917.

———. "Parade Protest Arouses Senate." March 5, 1913.

———. "Silent, Silly, and Offensive." January 11, 1917.

———. "Votes of Women and Bull Moose Elected Wilson." November 12, 1916.

———. "Wilson Backs Amendment for Woman Suffrage." January 10, 1918.

Painter, Nell Irvin. "Voices of Suffrage: Sojourner Truth, Frances Watkins Harper, and the Struggle for Woman Suffrage." *Votes for Women: The Struggle for Suffrage Revisited.* Edited by Jean H. Baker. Oxford, UK: Oxford University Press, 2002.

Parker, Alison M. "The Case for Reform: Antecedents for the Woman's Rights Movement." *Votes for Women: The Struggle for Suffrage Revisited.* Edited by Jean H. Baker. Oxford, UK: Oxford University Press, 2002.

Robbins, Dean. *Miss Paul and the President: The Creative Campaign for Women's Right to Vote.* New York: Knopf, 2016.

Russell, Charles Edward. "Is Woman Suffrage a Failure?" *Century Magazine,* March 1924.

Ruth, Janice E., and Evelyn Sinclair. *Women of the Suffrage Movement.* San Francisco: Pomegranate, 2006.

Sneider, Allison. "Woman Suffrage in Congress: American Expansion and the Politics of Federalism, 1870–1890." *Votes for Women: The Struggle for Suffrage Revisited.* Edited by Jean H. Baker. Oxford, UK: Oxford University Press, 2002.

Spruill, Marjorie Julian. "Race, Reform, and Reaction at the Turn of the Century: Southern Suffragists, the NAWSA, and the 'Southern Strategy' in Context." *Votes for Women: The Struggle for Suffrage Revisited.* Edited by Jean H. Baker. Oxford, UK: Oxford University Press, 2002.

Stevens, Doris. *Jailed for Freedom: American Women Win the Vote.* Troutdale, OR: New Sage Press, 1995.

Stovall, James Glen. *Seeing Suffrage: The Washington Suffrage Parade of 1913, Its Pictures, and Its Effect on the American Political Landscape.* Knoxville: University of Tennessee Press, 2013.

Syracuse Herald. January 15, 1917.

Terborg-Penn, Rosalyn. *African American Women in the Struggle for the Vote, 1850–1920.* Bloomington: Indiana University Press, 1998.

Walton, Mary. *A Woman's Crusade: Alice Paul and the Battle for the Ballot.* New York: St. Martin's Press, 2010.

Washington Post. "Ancient Attire Urged." February 3, 1913.

———. "Chief Blames Men." March 9, 1913.

———. "Colored Women to March in the Suffrage Parade." March 2, 1913.

———. "Failed as in Battle." March 12, 1913.

———. "Famed Women in Line." January 4, 1913.

———. "5000 of Fair Sex Ready to Parade." March 3, 1913.

———. "40 Congressmen Must March in Suffrage Parade or Explain." February 10, 1913.

———. "Give Votes to Women Is Advice by Wilson." January 10, 1918.

———. "Hearing on Suffrage." February 14, 1914.

———. "Help, Men, Help!" February 21, 1913.

———. "Indian Maid to Lead." February 9, 1913.

———. "Men in Police Attack." March 10, 1913.

———. "Order of the Suffrage Procession as It Will Line Up Monday Afternoon." February 27, 1913.

———. "Out with the Party that Fails to Give Vote to Women by National Amendment, Is the Plan of 'Militant' Suffragists." March 8, 1914.

———. "'Picket' White House." January 10, 1917.

———. "Police Must Explain." March 6, 1913.

———. "Pretty Girls Are Offered $2 to Parade, $3 Not to Parade." February 28, 1913.

———. "Pupils Will See Parade." February 20, 1913.

———. "Question of Suffrage Comes Before Congress." March 1, 1913.

———. "Siege of the Fair." February 22, 1913.

———. "Suffrage Leaders Give Their Reasons for Taking Part in Monster Parade." February 9, 1913.

———. "The Suffrage Parade." March 4, 1913.

———. "Suffrage Parade Facts." March 3, 1913.

———. "Suffrage War Opens." February 17, 1913.

———. "Suffragists Brave Police." January 30, 1913.

———. "Suffragists Take City for Pageant." March 2, 1913.

———. "Text of President Wilson's Fourth of July Address at Mount Vernon." July 5, 1918.

———. "Throngs Greet Pilgrims Entry." March 1, 1913.

———. "Woman's Beauty, Grace, and Art Bewilder the Capital." March 4, 1913.

———. "Women's March Plans Threatened." February 1, 1913.

———. "Women Tell of Insults." March 6, 1913.

Washington Times. "Women Who Engineered Suffrage Congress Victory." June 5, 1919.

Yellin, Carol Lynn, and Janann Sherman. The Perfect 36: Tennessee Delivers Woman Suffrage. Oak Ridge, TN: Iris Press, 1998.

Younger, Maud. "Revelations of a Female Lobbyist." McCall's, October 12, 1919.

Zahniser, J.D., and Amelia R. Fry. Alice Paul: Claiming Power. Oxford, UK: Oxford University Press, 2014.

INDEX

About the Author

Rebecca Boggs Roberts has been many things, including, but not limited to, journalist, producer, tour guide, forensic anthropologist, event planner, political consultant, jazz singer and radio talk show host. Currently, she is a program coordinator for Smithsonian Associates, where she has made it a personal mission to highlight the history of our capital city. Roberts lives in Washington, D.C., with her husband, three sons and a big fat dog. *Suffragists in Washington, D.C.: The 1913 Parade and the Fight for the Vote* is her second book. www.rebeccaroberts.org.

Visit us at
www.historypress.net